PHOTO FILTERS AND LENS ATTACHMENTS

By Kalton C. Lahue

Cover Design: Al Isaacs

BOOK DIVISION

Erwin M. Rosen
Executive Editor

Dick Fischer
Art Director

Darthe Twomey
Editorial Associate

COVERS:

Front cover: Raymond Pojman made three exposures of seascape on same frame of film to produce colorful effect. First exposure was ⅛ second at f/16 through No. 29 red filter; second was ¼ second between f/16 and f/22 through No. 61 green filter; third exposure was ½ second at f/16 with No. 47 blue filter. An explanation of this three-filter technique can be found in the chapter on color filters for color photography. Film was Kodak Vericolor II Type S; camera was 4x5 Cambo view camera with 210mm lens. Photo copyright© 1980 by Raymond Pojman.

Back cover: Photo at left was made by Kalton C. Lahue using laser-produced diffraction grating—see diffraction filters chapter. Photo at top right was made with Tiffen Vari-Color filter; photo courtesy of Tiffen. Photo at bottom right was made by Larry Hamill using colored strips cut from Cokin Creative Filter kit No. B 375, with 24mm lens used wide-open at f/2.8 to minimize depth of field and blend lines between filter strips; photo copyright© 1980 by Larry Hamill.

Inside front cover/title page: Orange filter and 16mm fisheye lens add contrast and impact to cityscape. While colored filters will have no effect on colorless gray skies, shadow portions of clouds are bluish and therefore darkened by yellow, orange or red filters. Photo by Mike Stensvold.

PHOTO FILTERS AND
LENS ATTACHMENTS
Vol. 5—Petersen's Photographic Library

By Kalton C. Lahue. Copyright© 1981 by Petersen Publishing Co., 8490 Sunset Blvd., Los Angeles, CA 90069. Phone (213) 657-5100. All rights reserved. No part of this book may be reproduced without written permission from the publisher. Printed in U.S.A.

Library of Congress
Catalog Card No. 80-83131

ISBN 0-8227-4044-3

PHOTOGRAPHIC MAGAZINE

Paul R. Farber/Publisher
Karen Geller-Shinn/Editor
Mike Stensvold/Technical Editor
Markene Kruse-Smith/Senior Editor
Bill Hurter/Feature Editor
Rod Long/Associate Editor

Franklin D. Cameron/Managing Editor
Peggy Sealfon/East Coast Editor
Allison Eve Kuhns/Art Director
Charles Marah/Far East Correspondent
Natalie Carroll/Administrative Assistant

PETERSEN PUBLISHING COMPANY

R.E. Petersen/Chairman of the Board
F.R. Waingrow/President
Robert E. Brown/Sr. Vice President, Publisher
Dick Day/Sr. Vice President
Jim P. Walsh/Sr. Vice President,
National Advertising Director
Robert MacLeod/Vice President, Publisher
Thomas J. Siatos/Vice President, Group Publisher
Philip E. Trimbach/Vice President,
Financial Administration
William Porter/Vice President, Circulation Director
James J. Krenek/Vice President, Manufacturing
Leo D. LaRew/Treasurer/Assistant Secretary

Dick Watson/Controller
Lou Abbott/Director, Production
John Carrington/Director, Book Sales and Marketing
Maria Cox/Director, Data Processing
Bob D'Olivo/Director, Photography
Nigel P. Heaton/Director,
Circulation Marketing & Administration
Al Isaacs/Director, Corporate Art
Carol Johnson/Director,
Advertising Administration
Don McGlathery/Director, Advertising Research
Jack Thompson/Assistant Director, Circulation
Vern Ball/Director, Fulfillment Services

Photo Filters and Lens Attachments

Introduction

Filters can add drama and interest to your pictures. (Photo by Hank Harris)

Filters and lens attachments are among the first accessories to attract the attention of newcomers to the hobby of photography. In fact, it's even money that you bought a skylight filter with your camera on the strength of the salesman's glowing description of its value in color photography, and as a protective device for the camera lens. Unfortunately, it's really the wrong filter to buy first, and those are the wrong reasons for buying it. No other filter does so little that the eye can see.

Why the attraction to filters and lens attachments? Comparatively speaking, there's more satisfaction involved for the money than with any other low-priced photo accessory. Even the increasingly expensive special-effect filters offer more enjoyment than any other accessory except an electronic flash. Small and compact, filters and lens attachments can add a great deal to your pictures, if used properly.

When I first became interested in photography years ago, a small handful of filters was sufficient to keep the creative juices flowing for months. I still recall my introduction to the magic world of filters—a four-filter, series 5 kit of solid glass Omag filters for use with black-and-white film—at a total cost of $9.95 including a "deluxe" folding leatherette pouch. Since that time, the number and types of filters have grown tremendously to the point of utter confusion these days—exactly what filters do you need, why do you need them, and what can you do with them?

There's nothing more discouraging than an accessory that is not used, unless it's one that's used incorrectly or inappropriately—which leads us to the major reason for this particular book on filters and lens attachments. Sure, there are a lot of other books on the market that deal with the same topic, but they delve into the ifs, ands, and buts, without ever offering concrete suggestions for practical applications.

As I see it, giving you a handful of spectrophotometric charts is a cop-out on the part of the author. The average amateur can't interpret the charts to begin with, and even those who can make heads or tails of the graphically presented information find it mostly useless when they're out in the field and faced with a decision to make—do they need a filter for this shot, and if so, which one? If it's theory you're looking for, this is the wrong place to come.

My purpose within the following pages is to acquaint you with the wide range of filters and lens attachments available so that you can buy the ones you need and use them intelligently. More to the point, I want to provide you with concrete suggestions for their selection and appropriate use to help you enjoy their magical effects to the fullest. No photo accessory can be of help to you if you really don't know what to do with it. Thus, you'll find this book broken into chapters, each of which deals with a specific type of filter or lens attachment. Each chapter explains how and why the particular filter or lens attachment works as it does, and provides suitable applications for its use, as well as suggestions for appropriate subjects. You won't have to search the book page by page to pick out information on a particular type of filter or lens attachment—it's all sorted out neatly for you in the table of contents.

To make certain that this book is as up-to-date as possible, I've searched out every possible type of filter and lens attachment presently available. Your local photo dealer should be able to obtain any one that he does not have in stock. Unfortunately, some dealers do not want to bother with such a small order. If yours tells you that he never heard of the one you want, or doesn't know where to obtain it, use the handy directory at the back of the book. Contact the various manufacturers and importers directly to determine the exact brand you want and then provide your dealer with this information. If he still cannot or will not obtain it for you, write directly to the source and explain your problem.

Now, let's take a look at some of the basic information you need to understand filters and how they work.

Light, Film and Filters

Filters are used in photography to modify the light rays reaching the film in your camera. By removing undesired wavelengths or portions of the spectrum, you can change the way in which the film records the image seen by your lens. To do so, you must first understand (1) what light is, (2) what filters do, (3) when to use one, and (4) how to select the proper filter to achieve the results you desire. By the time you have reached the end of this book, you will have a good working knowledge of filters and their effects, as well as a handy, useful reference guide that will answer future questions which are bound to arise.

The following chapters deal with individual groups of filters according to their usage. Lens or optical attachments often called "special-effect" filters are also treated in the same manner.

However, before you can work effectively with any of these light modifiers, you must have at least a passing acquaintance with the theory of light upon which their use is based.

Dozens of books have been written to explain how and why filters work as they do. Unfortunately, they spend so much time dealing with the concept of spectral absorption/transmission curves that the average reader searching for practical information loses interest. While it is true that spectrophotometric absorption curves are useful for those interested in scien-

The reasons for using filters are as varied as the subjects you photograph. This shot of Elephant's Head in Ausable Chasm, New York, was taken with a light green filter to provide separation between the foliage and rock formations.

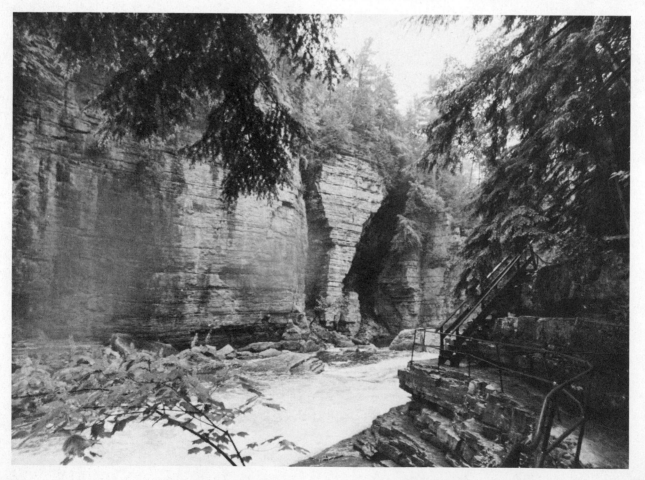

tific and technical photography, most of us couldn't care less about theory—we're interested in end results. For this reason, and because I have also suffered through such discussions of absorption/transmission curves, you'll find the technical *raison d'etre* held to an absolute minimum in the pages ahead. To make effective use of filters, you need only understand and remember the following theory.

The Theory of Light

What we call light is really a form of radiant energy. It travels in waves whose intensity diminishes in an orderly progression as the distance it must travel increases. Over the years, we have devised ways and means to measure both its quantity and quality using photoelectric light meters and color temperature scales. We speak of light as being "white," but it is really composed of varying wavelengths, each of which generates a particular color that remains constant according to the wavelength. If you've forgotten your high school physics, you can prove this to yourself with the help of a simple prism.

Directing white light through a prism refracts or breaks it into its individual components or colors. When taken together, these form a visible display or spectrum of the different wavelengths. Physicists are in agreement that white light is composed of three additive primary colors: blue (short waves), green (medium waves) and red (long waves). And where do all the in-between colors come from? Simple—all other colors are produced by combining the primary wavelengths in varying amounts. Pairs of these three additive primary colors also form three complementary colors: yellow, cyan and magenta. We call these subtractive primary colors because they are formed by removing one of the additive primaries from white light.

Figure 4 contains a traditional color wheel used to graphically represent the primary and complementary colors. By reference to this wheel, we can see that red and cyan are indeed complementary colors—when combined, they contain all three of the additive primary colors necessary to produce white light. Blue and yellow are complementary, as are green and magenta, and for the same reason. They produce white light when combined.

Since white light is the sum of the additive primary colors, it follows that black (the opposite of white) is the absence of all color. This occurs when there are no wavelengths of the visible spectrum present. When all wavelengths are present in equal amounts but in small quantities, gray is produced. Wavelengths also exist at each end of the visible spectrum to which the human eye is not sensitive. At the long wavelength end we find infrared radiation, which is a form of heat instead of light. Ultraviolet radia-

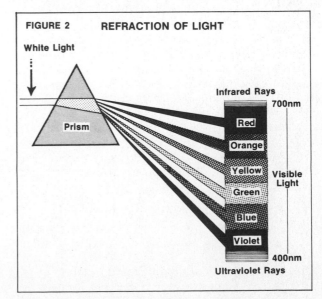

When white light is directed through a prism, it separates into its colored components.

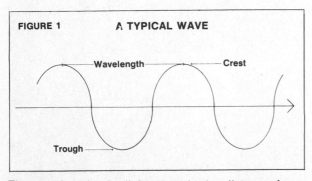

The wavelength of a light wave is the distance from one crest to the next.

tion is found just below the blue or short end of the spectrum. Like infrared, ultraviolet wavelengths are not light rays per se, but radiation.

Objects do not have color. The color of an object depends upon the wavelengths it reflects or does not reflect. The exact shade depends upon the reflective properties of the object, as well as the wavelength properties of the illuminating source. For example, I am wearing a red sweater. You see it as red because it has been treated with a dye that reflects red wavelengths. However, it may look slightly different in daylight than it does indoors by the light of a lamp. This is because daylight is composed of a higher percentage of blue waves, while light bulbs give off a light containing more red waves.

Only a very few light sources give off what we could call white light. But our eyes have the ability to adapt to various wavelengths, as well as to various levels of light. They become more sensitive to blue light when an object is illuminated by yellowish-red or tungsten lamps, and less sensitive to blue when a light source contains more blue wavelengths, such as daylight. Photographic film also has a sensitivity to color that can be described, but it does not have the ability to compensate for various wavelength mixtures or intensities.

Black-and-white films have what we call a spectral sensitivity. The basic light-sensitive element in a black-and-white film emulsion is ordinary silver bromide, which is sensitive only to blue and ultraviolet radiation. By treating the silver bromide with certain dyes that absorb radiations of longer wavelengths, it is optically sensitized. In this manner, the sensitivity of the emulsion can be expanded to include the green (orthochromatic), green and red (panchromatic), and even infrared wavelengths.

This spectral or color sensitivity of black-and-white film is important when it comes to selecting a particular film for a specific use. It determines how objects that reflect certain colors will photograph in gray tones (the basis of black-and-white photography), the types of filters that may be used to modify the tonal scale, and how the film is handled when it is processed.

Color film is "balanced" by its manufacturer to "see" certain colors under given conditions. A color emulsion balanced to see objects illuminated by daylight as normal will see the same objects under tungsten lighting as being too yellow-red. An emulsion balanced to see objects as normal under tungsten light can only see them as too bluish in daylight. Some nega-

tive color films can be used equally well under either type of illumination, since color balance is achieved by filtration during printing of the negative.

Now let's summarize what we've learned about light to this point:

A. Light travels in waves. The length of the wave determines its color as seen by the human eye.

B. White light is the combination of the three additive primary colors—red, blue and green.

C. Light waves form a spectrum. Blue light waves are the shortest in length and are found at one end of the spectrum. Red waves are the longest and are found at the opposite end of the spectrum.

D. As white is the sum of all colors, so black is their absence.

E. Taken by itself, an object does not possess color. It reflects certain parts of the visible spectrum and thus *appears* to have color.

F. Light sources vary in the composition of the light which they emit. Daylight contains a high percentage of blue while artificial light is

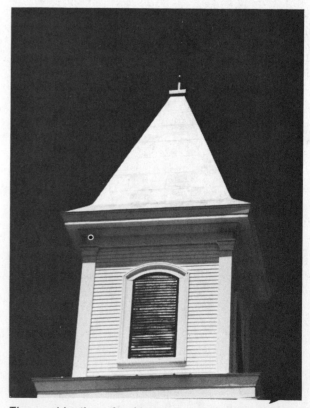

The combination of a deep red and a polarizing filter turn the New England sky black, throwing the white church steeple into sharp relief.

generally composed of yellow-red wavelengths.

G. A photographic film emulsion is sensitive to light in a predetermined manner; it cannot adapt as does the human eye. Such adaptation is produced by filtration of the light reaching the film's surface.

If you've followed me to this point, you now have a grasp of the basic chemistry of light and how it applies in photography. Since this is basic if you are to understand the use of filters, I'll refer to it occasionally in the chapters ahead, but for all practical purposes, we're almost ready to look at filters and see what they do and how they do it. But before we do that, let's take a brief look at the various light sources commonly used in photography and see how they influence the choice and use of filters.

Photographic Light Sources

Taking what we've learned about the nature of light, let's see how it applies to the various sources of light used by the photographer. "White" light, except in theory, is somewhat of a rarity. What we see and accept as white light

can vary in composition from bluish to a deep orange. Look outdoors and then step into a dark room and turn on the light. In both cases, we accept the illumination as being white, yet it isn't really white in either case. But film, as we've also seen, cannot make this kind of adaptation to changes in the composition of light. It records light exactly as it "sees" it. However, by introducing the proper filtration, it is possible to make the film react to light in a manner similar to that of our eyes.

Sunlight/Daylight

There is some difference between these two, although we tend to use the terms interchangeably. Sunlight is filtered by the atmosphere through which it passes, with the amount of filtration or scattering of the shorter (blue) wavelengths varying according to the sun's position in the sky. This means that the color of sunlight changes as the distance it must travel changes. When the sun is at high noon, the scattering of its rays (daylight) is minimal. But as the sun rises or sets, the angle its rays must travel is more oblique, and so they acquire a reddish cast—sunrise or sunset. (Figures 6, 7, 8)

Daylight, on the other hand, is a combination of direct sunlight and the scattered rays we call "skylight." This remains essentially the same in color, whether the sky is clear or filled with thin clouds. Color films balanced for daylight will deliver acceptable colors under a variety of "daylight" situations, but tend to give a somewhat bluish tinge to subjects lighted only by skylight (open shade) and reddish colorations to subjects lighted by a low rising or setting sun. These off-color casts can be eliminated by the proper filtration.

Tungsten Light

The exact color of this illumination depends upon the type of bulb used, but it's more reddish in nature than sunlight or daylight. Ordinary household lamps contain the greatest quantity of reddish coloration, with the amount of red diminishing as we move into the realm of special bulbs designed specifically for photographic purposes. Tungsten or indoor color film is balanced for use with these photographic lamps, but filters can be used to produce acceptable pictures with the more reddish forms of tungsten light, or even sunlight/daylight sources.

Fluorescent Light

This light source has a discontinuous spec-

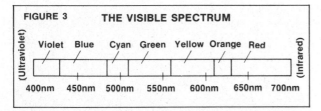

Light wavelengths run from just below 400nm (nanometers) to about 700nm. The shortest visible wavelengths produce violet and blue when they reach our eyes; the longest visible wavelengths produce red.

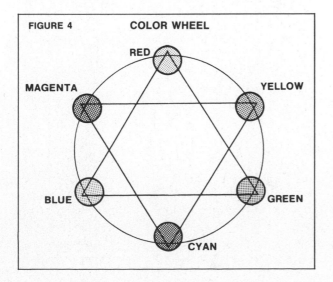

trum; that is, certain wavelengths are completely missing. Since color films are designed for use with continuous-spectrum sources, this form of illumination produces a deep blue-green or yellow-green effect which is also highly unpredictable. Filters are provided to modify the light, but the results are not always as expected. The ASA-EI 400 color print films produce far better results with fluorescent lighting than do other color films.

Electronic Flash/Flashbulbs

These provide a close approximation of daylight. To slightly warm the bluish light and produce a more visually pleasing effect, many electronic flashtubes use a gold-tinted filter. Clear flashbulbs emit a light slightly cooler than that of photographic lamps, but too warm for unfiltered use with color films.

UV/IR Radiation

These wavelengths cannot be seen with the human eye, as they are outside the visible spectrum. UV or ultraviolet rays are very short and thus very blue; infrared wavelengths are very long and thus very red. All films are sensitive to UV rays, but a photographic emulsion has to be specially treated to react to infrared radiation. Ultraviolet rays will produce a bluish coloration with color film, and a hazy effect with black-and-white film, but can be controlled through filtration. Special infrared emulsions must be filtered to remove the visible light and allow only IR rays to pass.

Mixed Lighting

Combining light sources such as daylight and tungsten, fluorescent and daylight, etc., can lead to highly unpredictable results, with areas lighted by each source taking on its primary characteristic. Such variations in light coloration cannot be tempered by the use of a filter,

A light-green filter lightens the water in the fountain, adding texture. For a different interpretation, you might try a dark red or blue filter.

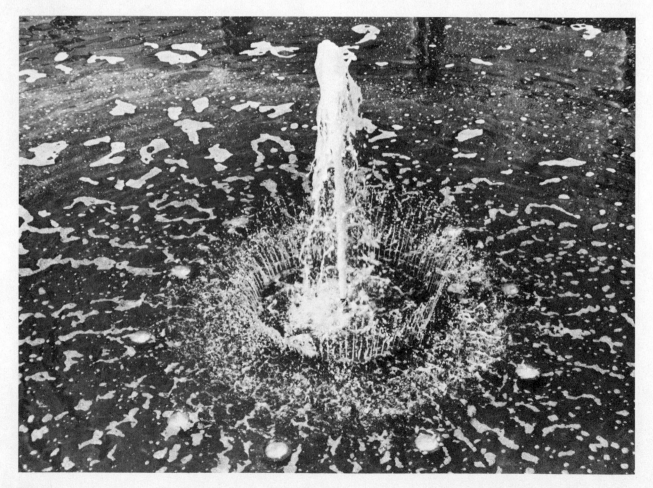

or by color printing filters in the darkroom. Unless a special effect is desired, the subject should always be lighted by a single type of light, whether daylight or artificial illumination.

How Filters Work

We've mentioned filters throughout the chapter, but what are they and how do they work? A filter is made by applying a dye or coating to a support or base material such as gelatin or optical glass. The dye used has certain light trans-

Color film has three "receptors" in the form of blue-, green- and red-sensitive layers of emulsion. As the original subject is exposed, a blue object forms a yellow image in the blue-sensitive layer of the film (A). When the negative is printed, or a reversal film is given a reversal exposure, this yellow image allows all light but blue to pass, forming a magenta image in the green-sensitive layer, and a cyan image in the red-sensitive layer (B). When the magenta (absorbs green) and cyan (absorbs red) images are seen together, they appear blue (white minus green and red), the color of the object in the original subject.

A yellow object in the original scene affects both the green- and red-sensitive layers of the film (C), forming a magenta image in the green-sensitive and a cyan image in the red-sensitive layer. When the negative is printed or a transparency given a reversal exposure, these images allow only blue light to pass, forming a yellow image in the blue-sensitive layer of the paper or slide film, which was the color of the object in the original subject (D).

mission/absorption characteristics that can be accurately determined and plotted on a bar graph, as shown in Figure 9. These are not really important for our purpose, but they are very necessary in maintaining a strict quality control standard during manufacture.

Filters vary in color and density according to the job they are designed to do. UV or haze filters, for example, are virtually colorless, yet they restrict the passage of ultraviolet rays. Other filters, such as those used in infrared photography and those designed to reduce the amount of all wavelengths reaching the film (neutral density), are virtually opaque.

Filters are manufactured for use on the camera lens or over a light source. Those used over a light source do not require any special care during manufacture, but filters used on the camera lens must be optically perfect to prevent image degradation. They must be kept clean for the same reason, and should fit the lens properly to prevent vignetting or the introduction of flare. All dyes are subject to fading regardless of how good the manufacturer's quality control, and older filters should be viewed with suspicion if they have been used a good deal, or stored under conditions that might cause changes in the dyes.

Special-effect filters do not absorb light rays as such, but they do produce various image changes that may or may not enhance visual appeal. For example, prism attachments multi-

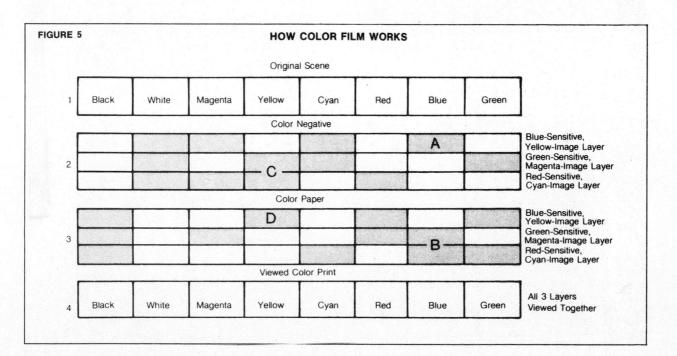

FIGURE 5 — HOW COLOR FILM WORKS

	Original Scene							
1	Black	White	Magenta	Yellow	Cyan	Red	Blue	Green

Color Negative — Blue-Sensitive, Yellow-Image Layer / Green-Sensitive, Magenta-Image Layer / Red-Sensitive, Cyan-Image Layer (row 2, with A and C)

Color Paper — Blue-Sensitive, Yellow-Image Layer / Green-Sensitive, Magenta-Image Layer / Red-Sensitive, Cyan-Image Layer (row 3, with D and B)

	Viewed Color Print							
4	Black	White	Magenta	Yellow	Cyan	Red	Blue	Green

All 3 Layers Viewed Together

11

ply and superimpose the subject image, while cross screens or star filters refract point light sources. Some special-effect filters like diffraction gratings, laser or rainbow filters produce a deep prismatic effect when used with point light sources.

Filters and Film

Black-and-white film reproduces its image in a series of gray tones according to the particular spectral sensitivity of the film. These tones do not always recreate the subject as we saw it. But we can use filters to modify the tonal reproduction and bring it closer to our visual experience by reducing the amount of certain wavelengths that affect the film, thus lightening some tones and darkening others.

Color films are manufactured to respond normally to a particular mixture of light rays. If the light source contains more blue or red than that for which the film is balanced, the photograph will take on an undesired coloration. Filters are also used to modify the light and allow only those rays that will produce the desired visual effect to reach the film.

Filters and Exposure

Those filters that absorb certain wavelengths require a longer film exposure. This exposure increase may take the form of a slower shutter speed or a larger lens opening. The additional exposure required is determined by a *filter factor,* expressed as a number and an X: 2X, 3X, 4X, etc. A factor of 2X means that the exposure must be doubled. This can be accomplished by opening the lens one stop wider, or by cutting the shutter speed in half. Thus, if the normal exposure without the filter is 1/250 second at f/8, a 2X factor would require an exposure of 1/250 second at f/5.6, or 1/125 second at f/8. We'll delve more deeply into filter factors and their use in a later chapter.

The rays of the sun travel through a greater amount of the earth's atmosphere early and late in the day than at noon. Particles in the atmosphere tend to scatter the shorter wavelengths of light. At noon, only the shortest wavelengths (blue) are scattered. The scattered waves give the sky its blue color. The remaining red and green wavelengths give the sun its yellow noon color. Early or late in the day, more of the sun's rays are scattered, because they travel through more of the atmosphere. Many of the green wavelengths are scattered, along with the blue ones; thus the remaining wavelengths from the sun give it a red color.

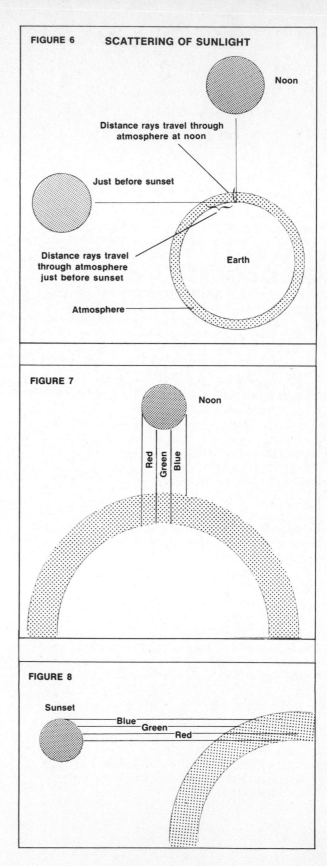

FIGURE 6 SCATTERING OF SUNLIGHT

Noon

Distance rays travel through atmosphere at noon

Just before sunset

Distance rays travel through atmosphere just before sunset

Earth

Atmosphere

FIGURE 7

Noon

Red Green Blue

FIGURE 8

Sunset

Blue Green Red

While exposure recommendations will be given in terms of f-stops throughout the following chapters, remember that a slower shutter speed will provide the same effect. You'll find filter factor recommendations in some of the tables used in the various chapters expressed in terms of ⅓ or ⅔ stop. For all practical purposes, these can be regarded as a half stop and the aperture ring adjusted to a point midway between full-stop settings.

Now, let's look at some of the basic information you need to choose and buy filters.

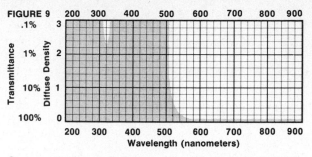

Spectrophotometric Data for No. 21 Deep Yellow Filter. (Courtesy of Eastman Kodak Company)

BRACKETING FOR EXPOSURE AND EFFECT

Throughout this book, you'll find references to "bracketing" your pictures when using special-effect filters. Bracketing simply means that you take one picture at the exposure recommended by your meter, then one with slightly more and one with slightly less exposure. Bracketing can be done at full- or half-stop intervals, and in series of three, five or seven—depending upon your subject and the need for a critical exposure. Generally, a series of three exposures taken at full-stop intervals will produce a suitable picture. With many special-effect filters, you'll find that the over- or underexposed picture will be more emphatic in its effect.

There's also a second type of bracketing which involves the use of special-effect filters. Many such filters deliver different effects at different lens openings. When using one of these filters, it's often a good idea to bracket a series at full-stop intervals. Since this involves a change of shutter speed with each aperture change, it may be necessary to use a tripod under some circumstances. The three- or five-stop bracket will result in a variety of effects from the filter, and until you're thoroughly familiar with what it will do to different subjects at different apertures, the technique of bracketing for effect is highly recommended.

EXPOSURE AND FILTERS

The filtering effect of any contrast filter used with black-and-white film is proportionate to the depth of its color. Since the filter will absorb certain wavelengths of light and transmit others, an increase in exposure is necessary. The amount of additional exposure required is calculated by the filter factor, which increases with the filter's color depth.

Even after applying the filter factor to the basic exposure, many amateurs have a tendency to give a "little extra" exposure when using a filter. Those with cameras that meter through the lens who rely on this method of exposure determination also end up giving the film a "little extra," since the meter's sensitivity pattern differs from the film's spectral sensitivity. In either case, the increased exposure beyond that absolutely required (as indicated by the filter factor) offsets the use of the filter.

Excessive exposure eliminates the filter's effect by passing too much of the very wavelengths the filter's supposed to absorb. Contrast filters used with black-and-white film should be used right on the edge of underexposure if you want their full effect. So the next time you're using a filter and are tempted to give that "little extra" exposure just to be on the "safe side," think twice before you open up the lens beyond the required filter factor.

Choosing Your Filters

A photographic filter may be positioned in front of or behind the camera lens. Regardless of where it is located, the filter must be of the highest optical quality to prevent image degradation. Photo filters are currently manufactured in four different types:

1. Gelatin sheets
2. Gelatin laminated between optical glass
3. "Dyed-in-the-mass" optical glass

4. Filtran© and other optically pure resinous plastics

In addition to these, acetate and dichroic filters are used in color printing systems. These

Choosing and using the appropriate filter depends upon the subject and effect desired. The dark sky provided by a deep red filter focuses attention on the subject.

Typical of the filter gel holders, the Kenko Technical screws into the lens and opens to accept gels.

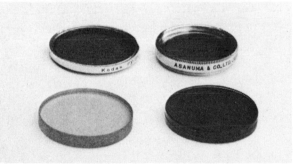

The Kodak and King filters at the back are solid glass in threaded rings. The solid glass and laminated filters in the foreground are series-type filters.

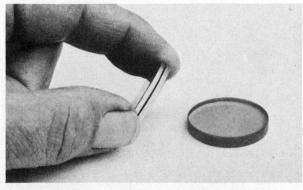

Laminated glass filters are manufactured of gel cemented between two pieces of optical glass.

will be treated separately in their own chapters.

Gelatin Filters

The least expensive to buy, gelatin filters are manufactured by dissolving organic dyes in liquid gelatin. This solution is then applied in a uniform thickness to a support base, usually of glass. Once it is dry, the gelatin is stripped from the base and cut into squares, the most popular of which is 3 x 3 inches. Gelatin filters offer the widest range of colors and possess excellent optical qualities, which makes them highly suitable for precision work. A special filter holder must be attached to the camera lens to use such filters.

Although coated with a protective lacquer, gelatin filters should be handled only by the edges or extreme corners. If the filter surface becomes smudged, scratched or otherwise abraded, it must be discarded. When not in use, gelatin filters must be stored flat and in a dark, dry place. Any lengthy period of stress will permanently deform a gelatin filter, while moisture will cloud it. Because they are so fragile and inconvenient to use, most amateurs resort to gelatin filters only when absolutely necessary to obtain a particular tint not available in other filter types.

Laminated Filters

Gelatin filters are often laminated or "sandwiched" between sheets of optical glass for protection. Many companies even seal the filter into a metal rim for additional protection. The once-popular (but now discontinued) Kodak Wratten filters are a good example of a high-quality laminated filter, as are the presently available Tiffen Photar® filters. Unfortunately, not all laminated filters are a good buy. Some manufacturers take the easy way out. They skip the gelatin and provide the color by adding dye to the cement used to bond the two pieces of glass together. To avoid such filters, stay with name brands, such as Tiffen, whose dyes have been carefully selected for stability in sunlight, maximum resistance to fading, and extreme temperature changes.

Although use of optical glass and a metal rim eliminates many shortcomings of the gelatin sheet filter, they still must be handled with care

and stored properly. Moisture is the greatest enemy of any laminated filter. If allowed to come in contact with the gelatin or cement at the edge of the filter, moisture can cause it to swell. When this happens, air is introduced between the gelatin/cement and glass, straining the filter and changing its optical surface.

Never clean laminated filters by washing with water, even if they are mounted in a metal rim. Cleaning should be done by breathing gently on the glass surface and wiping carefully with a soft, lintless cloth. If this does not remove the smudge, apply a drop of lens cleaner to a sheet of lens tissue and wipe the glass clean. You should never put lens cleaner directly on the glass surface and wipe with a dry piece of tissue. This technique may allow some of the liquid to reach the edge of the filter and affect the gelatin/cement inside.

Optical Glass Filters

Many filters used by amateurs today are manufactured of optical glass in which metal oxides are mixed into the glass when it is in a granular state. Once mixed and heated, it is formed into filter blanks. This produces a strong, permanent type of filter which is not prone to fading and can be handled without fear of damage. Optical glass filters are permanently mounted in metal rims and are the most convenient type to use, but they are not available in as wide a range of colors as the gelatin or laminated filters.

Simple cameras can also be fitted with filters. These Pro filters are designed to snap over the lens of Kodak 110 Pocket Instamatic cameras.

Optical glass filters also possess one significant disadvantage. Because of the nature of the metal oxides used to obtain the coloration, it is sometimes difficult to produce suitable spectral transmission qualities for a given color. It is also difficult to maintain such transmission characteristics from one batch of filter glass to another.

Such differences are of little significance with black-and-white work, but of extreme importance when using color materials. For example, it is virtually impossible to produce glass conversion filters that match the required 85/85B or 80A/80B transmission curves. Ultraviolet or UV filters of glass have a relatively poor UV absorbing ability, with few able to match the effectiveness of the 2B gelatin filter.

Optically Pure Plastics

The newest development in filter manufacture, these combine the best features of the gelatin and optical glass filters. Optical resinous compounds are mixed with dyes in a molten mass state to form a filter material that is more breakproof, shatterproof and scratch-resistant than glass.

Generally provided in squares for use in special filter holders (like gelatin filters), these form the basis for the new filter "systems" which are now appearing on the market. Unfortunately, some of the new system filters are manufactured of acrylic materials, which cannot be dyed in a mass state. Acrylic system filters must be surface-coated on each side, and difficulties in matching the coating on both sides have been known to occur. Some brands like the BdB Filtran filters are circular and permanently mounted in metal rims like optical glass filters.

Filter Quality

Whenever you place another piece of glass (or one of plastic) in front of your camera lens, you're introducing a potentially disruptive element to the carefully calculated optical formula. To paraphrase an old saying, if the manufacturer of your lens had wanted a filter there, he would have provided it; and some mirror-lens manufacturers do exactly that—they include a filter in the optical formula.

As a potentially disruptive element, the filter you use had better be as perfectly plane parallel and free from distortion as possible, its color mass should be uniform, and it must be free of all other optical imperfections—or your pictures will suffer. Remember, an expensive lens formula, no matter how carefully calculated, is only as

good as its weakest element—in this case, the filter you use. Many Japanese camera manufacturers offer their own brand of filters made to their own specifications by a single company—Hoya Corporation. Others sell filters under their own name, but manufactured for them by Tiffen. In either case, you are buying the camera manufacturer's name, for which you are charged accordingly.

Now, I'm not suggesting that you must buy an XYZ filter because you own an XYZ camera, but I am holding the XYZ quality level up to you as one to be attained in your own filter purchases. There are plenty of good filters and lens attachments offered by independent manufacturers, but there are also dogs in the same showcase. So know your manufacturer. An obscure off-brand name may be a bargain over the counter, but it could also be a disaster on your lens.

Color permanence is important. Despite the method of manufacture and what the filter companies will tell you, *all* dyes used in filter manufacture are subject to change from exposure to temperature extremes and light, and the more exacting control and quality that goes into the making of a filter, the better the end product.

Should you buy the new multicoated filters rather than the single-coated ones we've had around for years now? When the concept of multicoating was first introduced, everyone fell over each other to treat *every* air-glass surface in this way. But reason gradually prevailed and most lens manufacturers now use multicoating only when positive benefits can be shown from its use.

You may have read or been told that a multicoated lens requires the use of a multicoated filter. It's a good selling point for the accessory dealer, since multicoated filters are considerably more expensive than their single-coated brothers; but at the same time, it's not necessarily true. Image degradation from flare comes primarily from internal reflections in the lens or camera body rather than the filter. In fact, I doubt if you could tell the difference between a

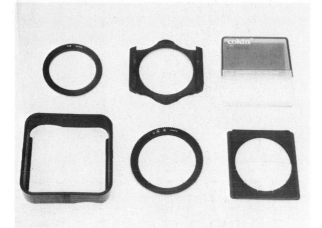

The newest approach in creative filtration, the Cokin® system by Minolta is a system approach derived from the older filter gel system.

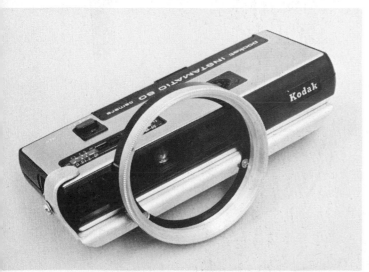

With a little ingenuity, you can make your own adapter to use filters on simple cameras.

Rangefinder cameras will also accept filters, but you will not be able to determine the effect in advance as with SLR cameras.

negative taken with a single-coated filter and one taken with a multicoated filter.

For this reason, I wouldn't advise replacing single-coated filters with multicoated ones, but if you're in the market for new filters and are persuaded that multicoating is the way to go, invest in them on that basis.

Filter Attachment Methods

How you attach filters to your camera lens will depend upon the lens and the type of attachment system you adopt. There are currently five different types of filter attachment systems available:

1. Screw-in
2. Bayonet
3. Slip-on
4. Series or Adapter Ring
5. Filter Holder

Screw-in Filter—This type is permanently mounted in a metal ring with a male thread at the rear to screw directly into the camera lens. The front of the metal ring contains a female thread to permit the use of a lens hood or other accessory. Screw-in filters are manufactured in sizes to fit virtually every lens mount from 22.5mm to 82mm and are most popular with amateurs who use roll-film or 35mm SLR and rangefinder cameras.

Bayonet Filter—This type is designed for use with twin-lens reflex cameras like the Rolleiflex or Yashica 124G. It is also mounted permanently in a metal ring, but the ring is fitted with a single bayonet instead of a screw mount.

Slip-on Filter—Used with inexpensive cameras whose lens mount is not threaded, this type slips over the lens barrel. It can be adjusted for a snug fit by bending the slotted prongs on the back of the filter. Use needle-nose pliers to bend individual prongs outward, but roll the

UNDERSTANDING FILTER DESIGNATIONS

The type and number of available filters have expanded considerably in recent years. Currently designated by a system of numbers, filters were formerly identified by an alphanumeric system applied to the once-popular Kodak Wratten filters. Since much of the literature still refers to the older alphanumeric system, here's an easy cross-reference between the old and the new designations.

Filter Color	Old Designation	New Designation
Light Yellow	K1	No. 6
Yellow	K2	No. 8
Deep Yellow	K3	No. 9
Yellow-Green	X1	No. 11
Dark Yellow-Green	X2	No. 13
Orange	G	No. 15
Red	A	No. 25
Deep Red	F	No. 29
Dark Blue	C4	No. 49
Blue	C5	No. 47
Green	B	No. 58
Deep Green	N	No. 61

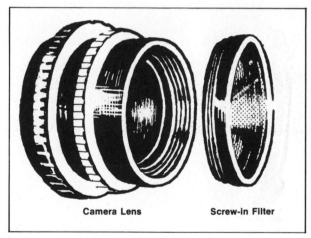

Camera Lens **Screw-in Filter**

Screw-in Filter Attachment

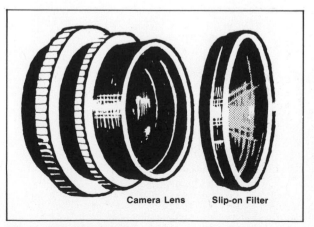

Camera Lens **Slip-on Filter**

Slip-on Filter Attachment

prongs on the edge of a hard surface while pressing down if you find it necessary to bend them inward. One or more prongs may be removed entirely to accommodate any protrusions on the lens barrel which interfere with the use of a slip-on filter.

Series Filter—Glass filters are manufactured in set sizes called "series" and designated as to size by a numeral ranging from 5 to 9. An adapter ring is fitted to the lens and the series filter held in the ring by means of a separate screw-in retaining ring. Adapter rings are available in screw-in, bayonet, slip-on and set-screw types to fit almost every lens from 19mm to 86mm. Those with more than one camera or several lenses will find series filters more economical, as the same filter can be used on each by buying separate adapter rings of the appropriate size and type. Certain special filter types which are not made available in screw-in

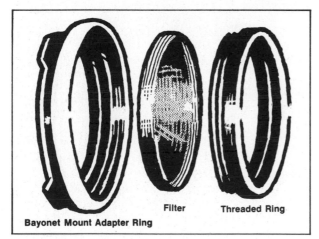

Bayonet Mount Adapter Ring **Filter** **Threaded Ring**

Bayonet Filter Attachment

mounts are offered in series type.

Filter Holder—Gelatin and system-type filters are attached to the lens by means of a special holder which mounts with an adapter ring. Some of these units will accept both square and round gelatin filters. Many also have provisions for accepting series-type glass filters as well.

Special Adapter Rings

Filter manufacturers have increased the versatility of these different attachment systems by providing a variety of metal rings to permit interchangeability between attachment methods. These are especially useful to amateurs who own two or more cameras or lenses which require different filter sizes, those who trade from one camera (and filter size) to another, or those who wish to use several different types of filters on a single camera.

The most popular and useful of these are the stepping rings. These are a series of thin metal coupling rings that have female threads on one side and male threads on the other. They are referred to as step-up or step-down rings, according to the particular combination of threads and direction of use. Step-up rings allow the use of larger filters on lenses threaded to accept a smaller filter size, while step-down rings work in reverse, permitting the use of smaller filters on lenses designed to accept a larger size. For example, to attach a 55mm filter to a 52mm lens mount, you'll need a 52-55mm step-up ring; if the lens takes a 55mm thread and you wish to use a 52mm filter, you'll need a 55-52 step-down ring. Step rings are usually engraved with numbers indicating their use; the first number always refers to the lens mount size and the second to the filter size that the ring adapts.

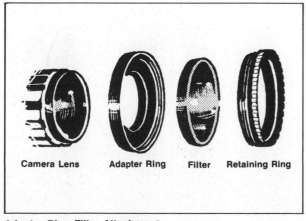

Camera Lens **Adapter Ring** **Filter** **Retaining Ring**

Adapter Ring Filter Attachment

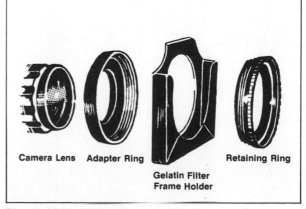

Camera Lens **Adapter Ring** **Retaining Ring**

Gelatin Filter Frame Holder

Filter Holder Attachment

These handy accessories can hold down your total investment in filters and lens attachments if your lenses require a variety of filter sizes, but they should be used with care. While rings are available which can adapt filters over a three- to five-step range (and even more if the rings are used in combination), it's not a good idea to use a filter more than one step smaller or three steps larger than that required by the lens. Using a filter that's too small can cause vignetting, while one that's too large might invite flare.

When using a step ring, it should be screwed partway into the lens mount. The filter is then installed, and both are tightened until just barely snug. Overtightening may cause the threads to bind, making it very difficult to unscrew the step ring from the filter and/or the lens mount. If you use step rings with any frequency, consider the purchase of a filter wrench. This simple but handy plastic device fits around the outside of the filter, ring or attachment and provides sufficient leverage to separate the two if binding does take place. Never tap the filter or lens mount in an effort to free threads that bind. This can cause permanent damage to the lens and/or attachment.

There are several other types of special adapter rings available. Four of the most common are described below.

Series-to-Series adapters permit the use of a given series filter in an adapter ring one series

Adapter rings are available in slip-on, screw-in and bayonet types. All use a retaining ring to hold the series filter in place.

Step rings are marked to indicate lens mount size (first number) and filter size accepted by the ring (second number).

Bayonet adapter rings and filters are designed for specific size bayonet mounts, and are used mainly with TLR cameras.

Screw-in filters are generally marked to indicate size, type and manufacturer.

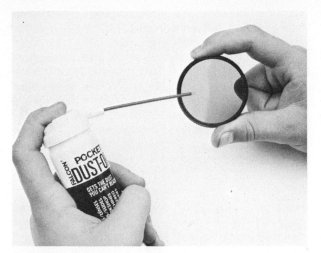

Blowing filters free of dust is the best method of cleaning them.

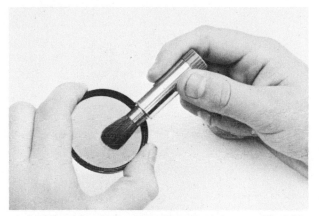

A lens brush will do an adequate job, provided it's used only for filter and lens cleaning.

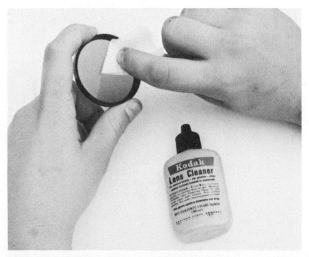

Use lens cleaner and lens tissue to remove fingerprints or smudges. Apply cleaner to tissue, not directly to filter surface.

BUILT-IN FILTERS

Extreme wide-angle and some telephoto lenses present special problems in using filters. Fisheye optics are a good example—the extreme curvature of their front element causes it to protrude beyond the lens barrel, making it impossible to attach filters in the regular manner. Other very short focal length wide-angle lenses will accept external filters, but their field of view is so great that vignetting occurs when a filter is used.

Mirror telephotos are another good example. Due to the size of the mirrors required to fold the light path properly, the lens barrel is considerably larger than telephotos of comparable focal lengths. In many cases, glass filters are not manufactured in large enough sizes to fit mirror lenses—the demand for such sizes would be small and the filters very expensive. In addition, adding a filter to the outside of such a lens would upset the carefully calculated optical formula.

Both problems are solved by building a filter system into the lens barrel. A ring which rotates on the turret principle is designed as an integral part of the lens barrel and contains three or four permanently mounted filters. The ring is click-stopped and can be rotated to select and position one of the filters provided in the optical path, correcting the light as it passes through the lens.

When a built-in filter system is incorporated in the lens, the manufacturer usually provides some combination of the following filter types: Skylight (1A), Color Conversion (80A), Yellow (No. 6 or 8), Green (No. 11 or 13) and Neutral Density 2X (ND2). A few such lenses will also accept rear-mounted filters. These standard-size filters screw into the rear element of the lens before it is attached to the camera body. This system permits greater flexibility in the filter types which can be used, but changing from one filter to another is a slow, tedious task better suited to studio work than photography in the field.

larger or smaller. In effect, these are step-up/step-down rings for use with series filters.

Thread-to-Series adapters allow the use of a screw-in filter with a series adapter ring.

Hasselblad-to-Thread adapters fit the Hasselblad lenses and accept the less-expensive 55, 58 or 62mm screw-in filters.

Double-Threaded retaining rings replace the screw-in retaining ring provided with a series adapter ring to hold the filter in place. Because it is double-threaded, it permits the use of two filters or a filter and lens attachment at the same time.

Keeping Filters Clean

Filters should be treated in the same way you treat your camera lens. In most cases, the use of a clean lens brush to remove dust and dirt from the glass surface will be all that's required. You can also use an aerosol spray can of compressed gas, but be careful that the can does not inadvertently squirt some of the propellant onto the filter surface, for this will necessitate further cleaning to remove it. Problems develop when you get smudges or fingerprints on one of the filter's surfaces.

To remove such contamination, fold a piece of lens tissue into a small pad. Moisten one corner of the tissue slightly with lens cleaner and,

There are many ways to store and carry filters. The stack cap concept (center top) is great in theory, but can give problems if threaded together too tightly. The various carry cases can be a nuisance when you have several filters.

Vivitar provides this individual plastic pouch for filter storage.

Below:
The individual Vivitar pouches fit into small booklike folders for storage.

using the pad with an index finger, touch the dampened pad to the center of the filter surface. Wipe in a spiral motion toward the outer edge. Never pour the lens cleaner directly onto the filter surface and then rub or wipe it dry. The use of distilled water is recommended if you should get water droplets or a splash of chemicals on the filter surface. Apply it sparingly to dissove the resulting spots in the same manner as you use lens cleaner.

Storing Filters

Filter care and protection becomes a problem once you've acquired more than one filter/lens attachment. Most filters and attachments are supplied in screw-together containers of hard plastic, although a few come in soft or padded vinyl pouches. Regardless of how they are

packed, the most important thing is to keep them protected properly from the possibility of scratching or chipping when not in use.

The "stack cap" concept of storage and carrying has become relatively popular in recent years. This simply involves screwing all of your filters together to form a single unit or stack and protecting it at both ends with a screw-in and screw-on cap. While very compact from a storage point of view, the stack cap method does have its disadvantages, which can easily outweigh the portability, especially once you have acquired a fair number of filters/attachments.

For reasons no one seems to be able to explain satisfactorily, dust still manages to work its way between the stacked filters, settling on their surfaces and making a thorough cleaning be-

Two types of sealed filter carry pouches.
Below:
The snap-type pouch contains a felt surface which can collect dust.

fore use necessary. This is particularly true when the filter stack is carried in a gadget bag and has not been used for some time. There's also the problem of screwing the stack together only to find that two or more filters have taken a ''set'' and will not easily come apart when you wish to use one of them. But most frightening is the possibility of dropping the stack while removing/replacing a filter—one little accident like this can ruin many dollars' worth of filters.

Carrying a wide variety of filters with you does pose space problems, but the best answer still remains the use of the case supplied with the filter. Write the type, filter factor and size (if more than one size is used) on the outside of the plastic case with a permanent ink marker. This will provide easy reference without your having to remove the filter from the case. Protect step rings in a similar manner by carrying them in their box instead of loose in your gadget bag or pocket. Their fine-pitch threads are quite susceptible to damage, and these simple accessories have become quite expensive to replace these days.

If using the filter cases annoys you, a good compromise can be found in the form of zipper-closure filter cases. These are offered by several different companies and are about the size of a tobacco pouch. They unzip to fold open and accept up to four filters in see-through acetate pockets or pouches. One of these can be tucked in a coat pocket and provide adequate protection from dust, dirt and damage, yet give near-instant access to four filters.

Now it's time to move into the world of black-and-white photography and see how we can use filters to rearrange the order of things.

Prinz pouches hold four filters in acetate sleeves and zip up to keep dust out. Labels attached to each pouch identify the contents.

Haze, Ultraviolet and Skylight Filters

The first filter purchase made by most amateurs will be a haze, skylight or ultraviolet (UV) filter. The sale is usually made at the suggestion of the camera salesman, who is quick to point out that its use will protect the camera's lens from damage or contamination. How much value it has beyond this point will depend primarily upon what you expect it to do for your pictures.

Despite what you may be told at the time of purchase, none of these filters will "cut through" fog or mist, so if you can't distinguish between these and atmospheric haze, you're quite likely to be disappointed in the results. True atmospheric haze is better handled by the use of a contrast filter for black-and-white film; with color film, you'll have to settle for whatever one of these filters will give you—there's no other alternative.

Atmospheric haze is caused primarily by the scattering of blue and ultraviolet wavelengths by dust particles and water vapor found in the atmosphere. Because black-and-white film is overly sensitive to these wavelengths, the effects of haze in the distance will be exaggerated in your picture. Distant objects will have a loss of detail and appear to be engulfed in a mist.

Since haze scatters some green but very little red and almost none of the infrared wavelengths, its effect can best be offset by using a contrast filter. As you progress from light to deep yellow through orange and to red, you'll progressively "cut" haze to produce greater clarity in distant objects. This is the most appropriate solution, as long as the change in tonal

Urban areas are especially prone to haze and smog. Notice how visibility decreases in this shot of the Empire State Building taken from the top of the RCA building.

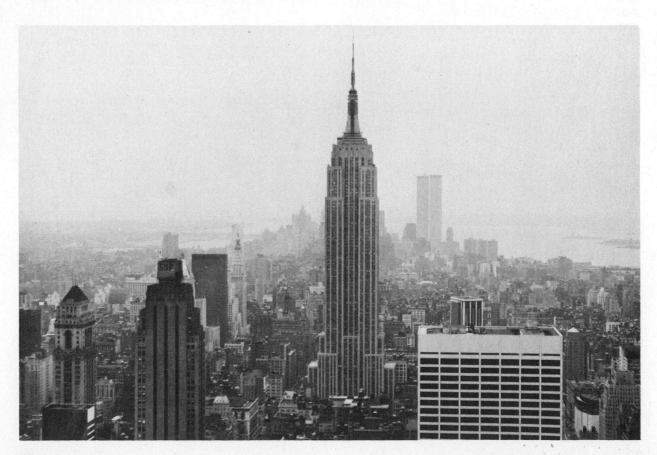

relationships caused by use of the filter is of no consequence. Red filters will reduce haze and its effects more effectively than even the human eye. On the other hand, there may be times when you wish to emphasize the effect of haze for creative purposes. If so, use a blue filter and you'll have all the haze effect you want.

Haze and UV Filters

The haze filter sold for use in black-and-white photography is really an ultraviolet or UV-absorbing filter. Since it is formulated only to prevent ultraviolet rays from reaching the film, this filter does not reduce the effect of haze in your picture. By absorbing ultraviolet wavelengths (which the human eye cannot see), it becomes an automatic filter whenever ultraviolet rays are present. If they are not present, it does absolutely nothing. For this reason, you can keep it on the lens regardless of what you're photographing. Since it absorbs no visible light, it has no filter factor and thus requires no increase in exposure.

These filters have a more appropriate use in color photography, but they are often useful when shooting black-and-white aerial pictures

Haze is also a problem when shooting aerials. The more oblique the angle, the greater the problem. (Photo by Hank Harris)

when the effect of a contrast filter might be too great or where it might alter tonal relationships in an undesirable way. When used with color film, both haze and UV filters will reduce haze and the bluish cast caused by ultraviolet wavelengths. They are particularly useful when photographing landscapes, taking pictures at the beach or in snow, or photographing subjects under an overcast sky or in open shade.

Haze and UV filters are usually offered in two or three different strengths. Which filter and which strength you select will depend to a great extent upon your personal taste in color rendition, the film you're using and what the camera store has in stock. You should be aware that some UV filters on the market are simply plain glass. This will absorb ultraviolet (you can't get sunburned through glass), but only the shorter wavelengths to which most black-and-white films are not sensitive anyway. In short, such filters are totally useless from a picture-taking standpoint.

Incidentally, Tiffen offers a filter designated as Clear which offers your lens the protection of optical glass without any color shift. Spiratone also has a similar item it calls an Opticap. Unlike the plain glass filters sold as UV filters, neither of these makes any claim to reducing haze or ultraviolet, but is offered primarily for lens protection. To tell whether you're buying a real UV filter or one of plain glass, check its coloration. The true UV filter will have a very slight yellowish tint; the plain glass filter will be colorless.

Skylight Filters

While haze and UV filters can be used with color film, the pinkish-colored skylight filter designated No. 1A is considered a good all-around choice for a basic filter in color work. Somewhat of a compromise between a haze filter and the weakest of the decamired filters (see chapter on Corrective Filters for Color Photography), a skylight filter holds back ultraviolet while adding a slight degree of warmth to your picture.

The skylight filter works best with American and Japanese color films. Haze or UV filters are a better choice with European color emulsions because they do not produce the muddy flesh

1

tones which are characteristic of the skylight filter when used with such films. Skylight filters are available in a single strength from virtually all filter manufacturers, but Hoya recently introduced a variation it designates the 1B.

Hoya's new skylight 1B filter eliminates the excessive bluishness in outdoor color photography caused by UV rays, especially in pictures taken in open shade under a clear blue sky. In addition, the new filter's absorption peak corresponds with the green sensitivity of current color emulsions. This eliminates greenish reflections in portraits taken under open-shade condi-

2

2 1

3

3 2

The effect of haze on a subject is unpredictable. No filter was used with photo No. 1, a UV filter in No. 2 only slightly improves matters, while the effect of a No. 25 red filter is shown in No. 3.

Under some conditions, even a No. 25 red filter (used in photo No. 2) will do little to cut through haze, but it can alter tonal relationships within the subject sufficiently to produce the illusion of increased haze penetration.

tions. What it amounts to is a fine-tuning of the original 1A filter which might very well pass unnoticed by many users.

Do you need one of these filters? Under most circumstances, I'd suggest that newcomers to the hobby resist buying any of them until they have taken a few rolls of color film under varying conditions and have had an opportunity to evaluate the results. Manufacturers have not made much of some optical advances, and one neglected the most is the fact that the majority of modern lenses are designed with ultraviolet filtration built into the optical system. For all practical purposes, using a skylight or haze filter with such lenses amounts to nothing positive, and can degrade image quality if the filter is dirty.

As for their use as lens protectors, this can become somewhat of a problem if you decide to add more than one or two lenses to your gadget bag. It will most likely introduce the near-constant use of step rings or else involve the purchase of a filter for each lens. The latter can become quite expensive, considering the use to which the filter is put and how seldom it will really be used.

FIGHTING TELE HAZE

Distant haze is most annoying to the photographer when working with long telephoto lenses. As you "eyeball" the scene, you note good contrast in the foreground and middle distance. But when you view the same scene through a 135mm or longer telephoto, the emphasis changes considerably. Since you're now filling the negative area with only a small part of what your eye originally saw, the distant haze plays a far greater role, causing a flattening of contrast and loss of detail at a time when crisp image reproduction is considered most important.

The problem is especially acute in black-and-white photography, since you're working entirely with tonal gradations of gray. Distant haze and a tele lens often combine to flatten the tonal scale sufficiently to destroy the differentiation among the different grays. Only a contrast filter will save the day here. On the other hand, the problem can actually turn out to be an asset in color work, depending upon the subject and composition. Since haze will lighten the colors, you'll often end up with pastel shades which can be combined with the flattened plane effect of telephotography to form an effective pictorial pattern.

Handling the problem best is really a matter of compromise—Mother Nature isn't too cooperative at times like these. To reproduce distant detail as sharp and crisp as possible, it's advisable to use your telephoto about two stops from the maximum speed—most long lenses will deliver their best contrast at that aperture. Slower film emulsions provide greater inherent contrast, making them the best choice for such photography. But when you add the exposure factor of a contrast filter to cut through the haze, you're apt to find the required exposure too slow to hand-hold the camera. Switching to a faster film will cause a loss of the contrast and resolving power needed in this situation, leaving you with (1) a long lens, (2) slow film, (3) increased exposure to compensate for the filter to be used—and the necessity of using a tripod.

Another possibility you might consider is a 50-percent overdevelopment of your film to add contrast in an attempt to overcome the flattened tonal scale. In extreme cases, this becomes a necessity in order to pick up sufficient image detail for printing, especially in urban areas where smog or smaze is an acute problem. Under such circumstances, you might even throw up your hands and forget the whole thing, but increasing development time to gain additional contrast is especially important if you're using a diffusion or cold-light type of enlarger.

Contrast Filters

A normal black-and-white panchromatic emulsion is sensitive to all visible colors, but in different degrees. To complicate the matter, the degree of its sensitivity to each of the primary additive colors differs considerably from that of the human eye, as shown in Figure 1. Unlike the eye, which unconsciously adapts to most forms of illumination, a black-and-white film emulsion reproduces only the tone(s) reflected by an object to which it is exposed. This disparity between what the eye and film see can be reduced and often eliminated by the use of contrast filters (sometimes referred to as correction or detail filters) which absorb some wavelengths while allowing others to pass through to the film.

A contrast filter will transmit only its own color, absorbing all other colors to some degree. Since contrast filters are manufactured in varying degrees of density, a lighter one will absorb less of the light rays than a darker one of the same color. Those colors which are farthest in wavelength from the filter's color will be absorbed first and to the greatest degree. The darker the filter, the greater the amount of absorption. For this reason, an orange filter will absorb more blue light than will a yellow filter, and a red one will absorb more than an orange. Because of this, any objects which reflect blue

To capture the mood of this scenic, Hank Harris used a green filter to lighten the foliage. This permits printing without having to burn-in the sky.

light rays will be increasingly darkened on the final print as you move from the use of a yellow to orange to red filter. To see how this works, let's look at one of the most common uses to which contrast filters are put.

When you look at a scene containing a blue sky and fleecy white clouds, your eye sees a distinct difference or contrast between the blue and white areas. You see the same thing when looking through your camera's viewfinder, so it's not unreasonable to expect that the camera will capture what you see—but it doesn't. That gorgeous view you saw in the viewfinder becomes nothing more than another flat, dull-looking scenic on the final print. The sky is light and the clouds are very faint, if they can even be distinguished. What went wrong?

As we've seen, the black-and-white film in your camera is overly sensitive to the blue part of the spectrum. Since the blue sky and white clouds are similar in brightness, the film sees very little difference in reflected tonal value between the blue and white areas. To correct this problem, you must filter out some of the blue light reaching the film. As this will reduce the amount of blue light striking the negative, the sky area will receive less exposure and thus reproduce darker on the final print. In this way, you have established a degree of contrast between the blue sky and the white clouds, just as it appeared when you looked through the camera's viewfinder.

A yellow filter is your answer. It will absorb part of the blue light that reaches the film from the sky area. This reduces the film's effective sensitivity to more nearly equal that of the blue part of the spectrum, as seen by the eye. Removing part of the blue light rays will produce the desired darker tones in the blue areas of the subject without changing the balance between the other colors. While you're using the yellow filter to create contrast in this instance, you're also using it to correct the difference between what the eye and the film see.

This effect can be accentuated by using an orange filter. In this case, you're distorting the tonal value of the sky to emphasize the clouds and the subject. A red filter will increase this tonal contrast between sky and cloud areas beyond the point of a normal appearance. In some instances, a red filter can darken the sky almost to the point of turning it black, a trick often used by architectural photographers. But as the orange and red filters absorb larger amounts of the blue light rays, they also cause greens in the picture to darken.

It's not unusual to find two contrasting colors with a similar degree of brightness. When photographed with black-and-white film, the two colors will blend into each other to the point of becoming indistinguishable. The traditional green Christmas tree with its red ornaments is a good example. Without a filter, the green tree and red ornaments will appear to be about the same shade of gray on the print. A red filter placed over the lens will absorb blue and some green light rays. This means that the tree will not expose the negative as much and thus appears darker on the print. Because the red filter transmits the red of the ornaments, they will expose the negative more than the tree, and thus appear to be light on the print.

Conversely, you could use a green filter in this case. Since the green filter absorbs blue and some red, the red ornaments will not expose the negative as much as does the green tree. The ornaments will appear as a darker shade of gray on the print while the tree, which has exposed the negative more than the ornaments, will appear lighter. In this particular example, the end result is very similar—regardless of whether a red or green filter is used.

In either case, the filter itself doesn't actually lighten either the ornament or tree in the pic-

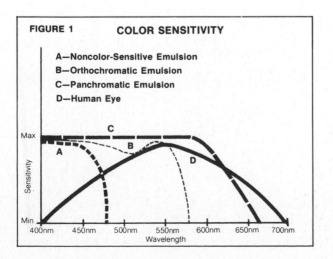

FIGURE 1 COLOR SENSITIVITY

A—Noncolor-Sensitive Emulsion
B—Orthochromatic Emulsion
C—Panchromatic Emulsion
D—Human Eye

ture. Because of their light-absorbing quality, contrast filters require an *increase* in exposure. This additional exposure means that light rays of the same color as the filter through which they pass are also proportionately increased, resulting in a degree of overexposure to that part of the subject. Looking back to the green filter and green tree, the increased green light rays will record darker on the negative and lighter on the print than normal. While the green filter doesn't actually lighten the green tree in your picture, the additional exposure required by its use will.

There are two schools of thought concerning exposure and the use of a contrast filter. The first and most common concerns filter factors. The second and equally logical position is called no-factor. Since both deserve to be

CONTRAST FILTERS AND COLOR PHOTOGRAPHY

Although designed for use with black-and-white film, the contrast filters can also be useful creative tools in color work. When chosen with care and used with some definite ideas in mind, the results can often be spectacular. The basic color of the filter used will impart an overall tint or cast (depending upon its strength) without eliminating other colors in the picture. Here are a few suggestions to add interest to your color photography.

1. Photograph a late afternoon sun with an orange filter to produce a false sunset effect.

2. Use a deep red filter to play up strong highlights, such as sunlight sparkling over large expanses of water.

3. Create pseudo-moonlight effects with underexposure and a blue filter.

4. Make multiple time exposures of moving lights at night using different color filters.

5. Make multiple slow exposures of objects such as water fountains during daylight, using different color filters.

6. Make multiple exposures of an object that can be repositioned between each exposure. Use a different color filter for each exposure.

When using contrast filters with color film, remember that filter factors still apply, and increase the exposure accordingly or you'll lose important detail due to underexposure. Since photography offers a wide choice of options and opportunities for abstract design and unique expression over and above a ''true'' rendition of the subject, free the artist in your soul and ''create'' your pictures with filters.

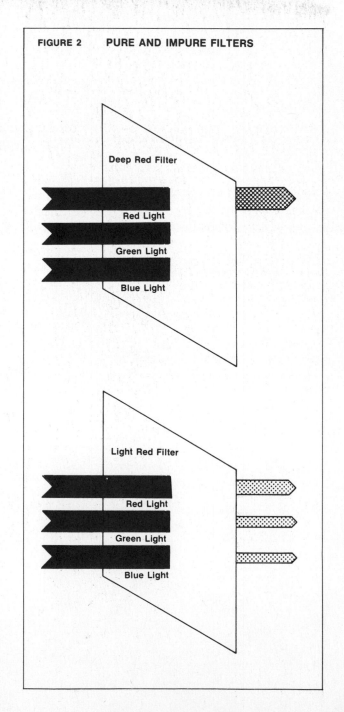

FIGURE 2 PURE AND IMPURE FILTERS

Deep Red Filter

Red Light

Green Light

Blue Light

Light Red Filter

Red Light

Green Light

Blue Light

heard, let's examine them in turn, beginning with the traditional filter factor approach.

Filter Factors and Exposure

Since a contrast filter absorbs colors other than its own, it reduces the overall amount of light reaching the film. This results in underexposure of the subject on the negative. To prevent such underexposure, we use a rule of thumb called a filter factor. This is simply a number provided by the filter manufacturer to help you determine how much the exposure should be increased whenever a particular filter is used. The filter factor is expressed as a number and an X—2X, 3X, 5X, etc. It is included on an instruction sheet provided with the filter, as well as on the data sheet included with each roll of film. The factor is usually engraved on the filter ring along with the type, color and size (Yellow

49 2X). Filter factors are also referred to as Exposure Magnification or EM values.

A factor of two (2X) means that the exposure should be doubled, while a factor of four (4X) requires four times as much exposure. Such calculations can be simplified by referring to Figure 3. While this increase in exposure is usually given in terms of f-stops, it can also be made by changing the shutter speed to a slower one. To do so, multiply the shutter speed which would normally be used by the filter factor. The result is the new shutter speed for use with the filter. Thus, a 2X factor applied to a 1/125-second shutter speed results in a new speed of 2/125, or 1/60 second. Figure 4 offers a handy reference at a glance for common filter factor/shutter speed combinations.

But how do you accommodate a factor of 3X or 5X? Translated into f-stops of exposure, a 3X factor requires one and a half stops; a 5X factor requires two and a half stops. This can be handled entirely by adjusting the lens to compensate for the required increase, or you may reduce the shutter speed in increments to accommodate the full-stop increase(s) and open the lens by the required fractional stop. In practice, here's how it works. Let's say the basic exposure is 1/250 at f/8, but I wish to use a filter with a 3X factor. Applying this factor to the basic exposure, I can use 1/125 at f/6.3 or I can leave the shutter at 1/250 and open the lens to f/4.5. My choice will depend to some extent upon the subject's requirements for depth of field or an action-stopping speed.

One caution is in order here. A specific filter is assigned a given factor by its manufacturer. This factor, however, may not apply equally to all film emulsions. For example, the factor may

FIGURE 4

SHUTTER SPEED COMPENSATION FOR FILTER FACTORS

Normal Speed	Filter Factor 2X	4X	8X	16X
1/1000	1/500	1/250	1/125	1/60
1/500	1/250	1/125	1/60	1/30
1/250	1/125	1/60	1/30	1/15
1/125	1/60	1/30	1/15	1/8
1/60	1/30	1/15	1/8	1/4
1/30	1/15	1/8	1/4	1/2
1/15	1/8	1/4	1/2	1
1/8	1/4	1/2	1	2
1/4	1/2	1	2	4
1/2	1	2	4	8
1	2	4	8	16

FIGURE 3 — APERTURE COMPENSATION FOR FILTER FACTORS

Normal Aperture	Filter Factor 1.5X	2X	2.5X	3X	4X	5X	8X	16X
f/2	f/1.6	f/1.4	—	—	—	—	—	—
f/2.8	f/2.2	f/2	f/1.8	f/1.6	f/1.4	—	—	—
f/3.5	f/2.8	f/2.3	f/2.2	f/2	f/1.8	f/1.4	—	—
f/4	f/3.2	f/2.8	f/2.5	f/2.2	f/2	f/1.6	f/1.4	—
f/5.6	f/4.5	f/4	f/3.5	f/3.2	f/2.8	f/2.2	f/2	f/1.4
f/8	f/6.3	f/5.6	f/5.2	f/4.5	f/4	f/3.2	f/2.8	f/2
f/11	f/9	f/8	f/7	f/6.3	f/5.6	f/4.5	f/4	f/2.8
f/16	f/12.5	f/11	f/10	f/9	f/8	f/6.3	f/5.6	f/4
f/22	f/18	f/16	f/14	f/12.5	f/11	f/9	f/8	f/5.6
f/32	f/25	f/22	f/20	f/18	f/16	f/12.5	f/11	f/8

be given as 2X by the filter manufacturer, but when you consult the data sheet accompanying the film, you discover that the film manufacturer's filter factor recommendation for that particular filter may differ. This points up an important fact regarding filters and exposure increases. The filter factor is only a *guide* provided by the manufacturer, and should be tested, verified and/or adjusted by the user—just as with a flash guide number.

Filter factors *will* differ when using the film in tungsten light, and some manufacturers will provide one set of factors for use with daylight and a second set for artificial illumination (electronic flash is considered as daylight for this purpose). Depending upon the film's spectral sensitivity, different factors are required because of the difference in the wavelengths which constitute tungsten and daylight illumination. One contains more red and the other has more blue.

Single-lens reflex camera manufacturers recommend that you simply place the filter to be used over the lens. The camera's through-the-lens metering system will make the necessary adjustments in exposure with no effort on your part. Unfortunately, this does not always happen as stated. Like film emulsions, the metering cells used in cameras have their own light sensitivity range and pattern, and the two are not always the same across the entire light spectrum. For example, CdS cells are highly sensitive to red and thus do not compensate fully for the use of a red filter. When a meter reading is taken by CdS cells through a red filter, you generally have to add another 1½ stops manually for a correct exposure.

Depending upon the type of cell in use, its placement and how it reads, different in-camera meters will arrive at different exposure corrections, which may or may not be on the button. Most such meters cannot compensate completely for the poor sensitivity of normal black-and-white film to red. When orange and red contrast filters are used, an additional exposure increase beyond that made by the camera is usually required for optimum results. In general, a minimum increase of ½ f-stop with an orange filter, and 1½ f-stops with a red filter is necessary in addition to the correction made by the camera's meter.

The same holds true for hand-held light meters. Holding the filter over the metering cell

Right:
Noted French photographer Jean Coquin combined the use of a Cokin Star 8 and graduated pink filter for this striking photo of a glider at rest. (Courtesy Minolta Corp.)

FIGURE 5		RECOMMENDED FILTER USES, BLACK-AND-WHITE FILM
Filter	**Factor***	**Use**
Light Yellow	2X	Slightly darkens sky to bring out clouds; absorbs some UV for haze penetration; improves contrast between subject and sky. Lightens yellows, darkens blues.
Yellow/ Green	2X	Similar in effect to light yellow, but also lightens foliage somewhat; works well for outdoor portraits and beach pictures, but does not lighten suntanned skin tones.
Dark Yellow	3X	Similar to light yellow, but more pronounced in effect. Emphasizes foreground subjects and increases shadow contrast in winter snow scenes; works well when photographing light-colored woods.
Green	2X	Lightens greens to help contrast in pictures containing much foliage, trees, flowers, etc., emphasizes detail and improves cloud effect; will darken suntanned skin tones but beware of freckles. Lightens greens, darkens orange and reds.
Orange	4X	Produces a strong cloud effect, increasing contrast in outdoor scenics while absorbing UV and eliminating haze. This makes it good for distant landscapes, scenics and aerial work. Subdues lips and facial blemishes such as freckles; useful for better rendition of brick and stone surface textures, as well as photographing dark-colored woods. Lightens reds, orange and yellows, darkens blues and greens.
Red	8X	Cuts haze, produces strong contrast leading to exaggerated cloud effects; with slight underexposure, produces simulated night effects. Works well for architectural photos when building is light in color, as it sets it off against a very dark sky. Try this for sunsets in black-and-white, and for copying blueprints and other such documents. Lightens reds and yellows, darkens greens.

*May vary according to density of filter and manufacturer.

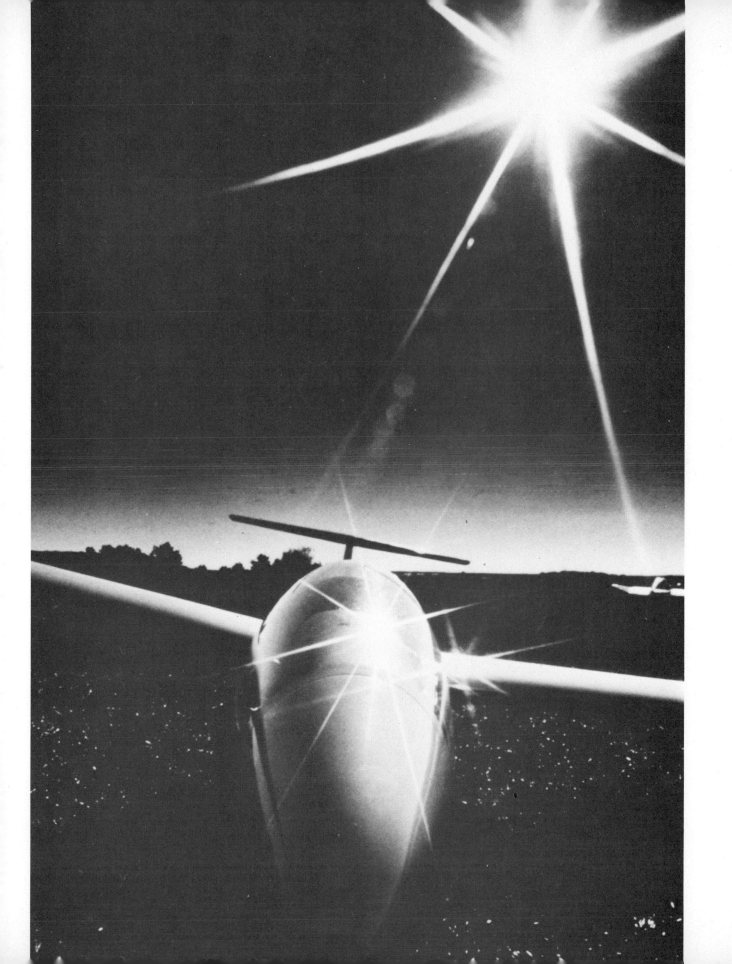

window will result in the meter compensating somewhat for the filter's presence, but this technique does not work with any greater accuracy than that of the SLR with the built-in metering system. The most accurate way of compensating for the use of a filter is to take a normal light meter reading, whether hand-held or through the camera lens, and then apply the filter factor manually to the camera's exposure system. However, this tends to confuse some amateurs, and cannot be used satisfactorily with the newest SLR cameras which have no shutter speed dials.

Probably the fastest and most efficient way to compensate for the use of a filter with any camera or light meter is to divide the factor into the normal ASA-E.I. speed of the film being used: 64 divided by two equals 32, 125 divided by four equals 32, 400 divided by eight equals 50, etc. Set the camera's meter at this new ASA-E.I. rating or the one closest to it while using the filter. But don't forget to reset the meter to the normal ASA-E.I. speed when you remove the filter. Users of fully automatic cameras with an exposure compensation adjustment can also make limited use of that device; most such devices will permit up to a 3X compensation, which will in turn accommodate a 3X filter factor.

Regardless of which method you choose to compensate for the filter factor, you should be able to work with the concept in your head and be able to arrive at an exposure adjustment for each filter without difficulty. Whenever you're in doubt, a slight amount of underexposure is always preferable to overexposure. Too much exposure lessens the effect of a contrast filter, but underexposure will help to increase the effect. With the wide exposure latitude of current black-and-white emulsions, you can even ignore a 2X factor completely if you choose, without adverse effect to the negative.

No-Factor Exposure

This school of thought recommends that you expose for the darkest major object in the scene that is substantially the same color as the filter being used, letting the filter absorb the other colors. Using a red filter with its 8X factor as an example—increasing the exposure eight times will overexpose any reddish objects in the scene by almost eight times, as the red filter

Left:
An overcast, rainy day in Ausable Chasm, New York, calls for the use of a light green filter to separate the rock and foliage tones in this shot of Elephant's Head, the rock configuration in the center.

A QUICK GUIDE TO BASIC CONTRAST FILTERS

YELLOW—The most popular is a light yellow (No. 8) with a factor of 2X. This provides normal tonal rendition when used with panchromatic film in daylight. It darkens blue skies enough to provide contrast with white clouds. A deep yellow (No. 9) accentuates this effect, but has a 4X factor.

GREEN—The light green (No. 11) darkens skies, but also lightens foliage. This makes it a good choice for many scenery shots. It's also useful in holding a suntan in outdoor portraits. The dark green (No. 13) renders flesh tones deep and swarthy, making it a good choice for portraits of men taken under tungsten lighting.

ORANGE—A light orange (No. 15) provides more contrast between sky and cloud than the yellow filter family. It will also lighten yellowish brick and woodwork, etc. Since this filter darkens greens, it should be used with care in scenics in which green predominates. It lightens skin tones to a point which may make the subject look anemic and unhealthy.

RED—Several varieties are available, of which the No. 25 (A) is the most useful for general work. It creates dramatic sky effects, produces a simulated moonlight effect when combined with underexposure at midday, and provides maximum penetration of fog, haze and mist when used with infrared film. The red filter darkens greens but bleaches skin tones, especially those of females.

BLUE—Seldom used as a basic contrast filter, the No. 47 (C5) offers interesting effects. It accentuates haze and fog, darkens reds such as lipstick and freckles, lightens blue skies and darkens yellowish brick and woodwork, etc.

transmits almost all of the red light waves. Such an excessive increase in exposure will cause a loss of much detail in the red objects in the final print. To see why, let's examine the problem more closely.

Imagine that you're photographing the stereotyped midwestern scenic—a large red barn and silo in a grassy field, surrounded by acres of waving corn and backed by a blue sky that contains large, fleecy white clouds. What happens when you place the red filter over the lens and increase the exposure by 8X (three stops)? The filter transmits nearly all of the red in the building and silo, rendering it far too dense or "blocked-up" on the negative. When printed, the building will appear washed-out and lacking detail. At the same time, the increased exposure effectively cancels out the blue and green absorption effect of the filter. As it ab-

sorbs most of the blue and green, the sky and corn should be rendered lighter than normal on the negative, but the three-stop increase in exposure causes them to appear about normal. If you have followed me to this point, you'll see that you really haven't darkened the sky—you've simply destroyed the detail in your main subject, the building and silo, by underexposure. You can print the negative to compensate for this by increasing the exposure in the enlarger, but you'll still experience lost detail and increased graininess from the overexposure given the film in the camera. So what's the answer?

According to the No-Factor concept, you should expose for the main subject—in this

A bright July day in Vermont provides the setting for this series illustrating the different effects of various contrast filters.

1. Light Yellow Filter

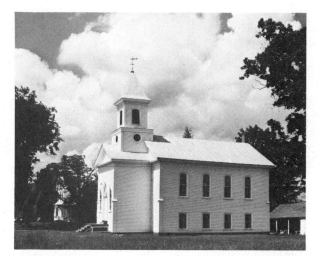

2. Green Filter

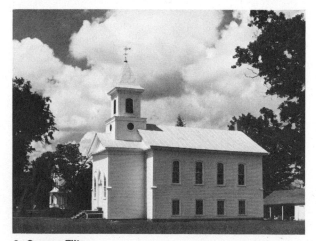

3. Orange Filter

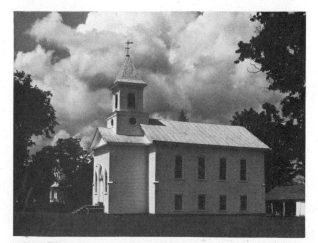

4. Red Filter

Aerial haze can be eliminated by using a contrast filter. (Photo by Hank Harris)

case, the building and silo. Take a spot meter reading of the building with your light meter/camera meter and expose according to that. If you don't have a spot meter, or if your camera meter is one of the averaging or center-weighted type, try to move in close enough to the subject to assure that the reading is not influenced by other elements in your composition, then move back to your original position. In this way, you'll expose the building and silo correctly. This leaves them full of detail, while the red filter will absorb much of the blue in the sky, darkening it to provide the desired contrast between the sky and clouds.

The No-Factor concept applies only when using a filter which is the same color as a major subject in your picture. If the building is green, use a green filter and expose for the building—the sky will still be darkened. Using a red filter in this case will cause the green of the building to be absorbed and it will go black, with the resulting lack of detail. Use a yellow filter with a yellow building, etc. If there is no major subject in your picture that is the same basic color as the filter you're using, you either have an unusual subject or you're using the wrong filter. As with everything else in photography, choosing the correct filter for the required effect means some forethought on your part. You must know what you want in the final picture, and which filter will provide the desired results. Along the way to this knowledge, experimentation will prove to be a valuable tool.

Don't Expect Too Much From Filters

We've all seen those magnificent architectural shots in which the building stands out in contrast to a near-black sky. But can you duplicate the effect? It may come as a surprise, but the answer is—not always. For the purposes of this discussion, I'll restrict my remarks to the red filter and its use, since this one tends to give the maximum effect.

How much any filter darkens a blue sky is very much dependent upon atmospheric conditions. A red filter can darken a really deep blue sky sufficiently to turn it into that near-black we admired so much in the picture mentioned earlier. But under average conditions, the amount of darkening is generally much less, and when the blue is actually a pale shade, there will be very little darkening. This is particularly true in temperate regions, as well as in urban areas where atmospheric haze and smog tend to reduce the brilliant blue sky to a light, somber one. Under such circumstances, a red filter is often the only

possible way to emphasize weak cloud formations in the sky, and even then, its effect is not as strong as you might expect.

There are days when the sky will be a very light blue at the horizon line, with the color deepening as it reaches the zenith. Photographing the sky near the horizon line will result in little or no darkening effect from a filter, but the effect will increase as the camera is pointed upward. Since the sky near the sun will not be as blue as that at a midpoint between sun and horizon, the greatest darkening effect will be achieved at this midpoint.

How well a filter works depends upon the re-

Right:
A contrast filter lightens objects which reflect its color, and darkens those of a complementary color. The Christmas table decoration shown in photo No. 1 was taken without a filter. A green filter was used for photo No. 2, and a red one for photo No. 3. Note the change in tonal relationships.

1

2

Depending upon sky conditions, a red filter may not provide a dark enough sky (photo No. 1), but add a polarizer to the red filter (photo No. 2) and you'll get the desired result.

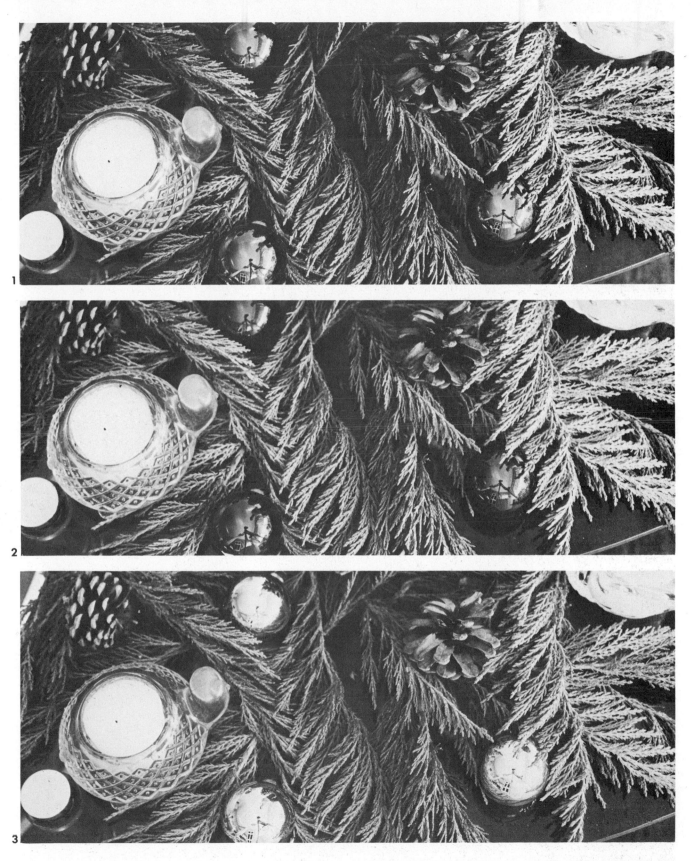

1

2

3

flectance value of the object(s) in question, and there's no precise way for you to determine this in advance. For example, a red filter will darken greens, but you may be surprised at the effect during the spring and early summer months when pale greens are abundant. If a scenic contains such a mixture, the red filter can exaggerate the differences between the greens instead of blending and darkening them. This means that the red filter will further darken the darker greens, but actually lighten the lighter ones, which tend to reflect more red light. A helpful, but by no means foolproof, rule of thumb is to look through the filter at your subject. This will give you some approximation of its effect on the various colors in the picture.

SELECTIVE FILTER SELECTION

You should know in advance exactly what it is you wish to accomplish with a filter before choosing and using one. For example, it there's haze in a landscape, we reach automatically for a red filter to eliminate as much of it as possible. But is the red filter always our best choice? Not necessarily—it depends upon what we wish to emphasize within the picture's area.

To examine this concept, let's divide our picture area into three distinct segments or thirds—foreground, middle and distant areas. If subject emphasis is desired in the front third or foreground, a No. 6 or UV filter should be sufficient for our purpose. In this case, absolute elimination of the haze is not really desirable, as the sharp, distinct horizon may actually cause a distracting visual conflict or confusion.

When the greatest importance lies in the middle part of the picture, you'll find a No. 8 filter to be a more appropriate choice since its effects will visually extend to that area. But if the horizon line is to be the major point of interest, the best choice is more likely to be the No. 15 filter. Keep the red filter in reserve and use it only when maximum impact is desired.

Using Contrast Filters

The choice of filter depends upon the desired effect. Do you want to bring the film's sensitivity in line with that of the eye, or do you wish to alter the tonal relationship between different areas within the picture? Before offering some specific suggestions, let me state another rule of thumb used by many photographers to guide their choice of filter.

To lighten an object, use a filter of the same color. To darken an object, use a filter that is complementary in color. To bring out detail and texture in an object of uniform tone/color, use a filter of the same color as the object.

The use of a light yellow filter will "correct" the film's sensitivity and restore some of the missing contrast between blue sky and white cloud, but a darker yellow or yellow-green filter will add more zip to landscapes. The yellow-green filter will darken the sky in the same manner as the yellow one, but it will also lighten grass and foliage to produce more detail and texture. This can be very useful during midsummer months when foliage has a tendency to re-

An orange filter (photo No. 2) will lighten many wood tones which would otherwise reproduce too darkly to show sufficient detail of the wood grain.

produce as a very dark gray on normal panchromatic film. It's also useful when taking pictures of people outdoors, especially if the subject has a suntan. The green aspect of the filter produces a healthy look in the red-brown tan, while the yellow lightens blonde hair.

Artificial light contains far more red than blue wavelengths. For this reason, a pale blue filter adds life to skin tones. The light-blue filter is also useful outdoors under certain circumstances. Shadows in a subject photographed under a blue sky will contain blue light, causing them to reproduce darker than normal. A pale-blue filter will increase whatever shadow detail is present, yet retain any atmospheric haze that may be present.

Keep in mind that a contrast filter will affect the film only when there is color present for it to work on. You can't darken an overcast gray sky or lessen the effects of white mist with a contrast filter, as there is no color for it to absorb and thus darken.

Contrast filters have many other uses. When copying a document or photograph which has a stain, the defect can be eliminated by using a filter of the same color as the stain. When doing copy work, it's worth remembering that yellow, orange and red all reflect a high percentage of red light. This means that a red filter will turn yellow, orange and red lettering on a white background nearly invisible, provided the inks used contain reasonably pure dyes or pigments. Blue or green lettering on a white background photographed through a blue or green filter will show little change. Again, the answer lies in reflectance values. When green paint, dye or ink is subjected to a spectrophotometer, its maximum reflectance will rarely exceed 40 percent, yet yellow, orange and red test out to a reflectance value of 85 percent or more.

Detail and texture can be separated in subjects that are otherwise nearly uniform in tone and color, such as sand, wood grain, brickwork, etc., provided a filter similar in color to that of the subject is used. Figure 5 will help you decide which particular filter is most appropriate with a given subject, but I urge you to experiment until you feel confident that you know and understand what a particular filter will do under various circumstances and situations.

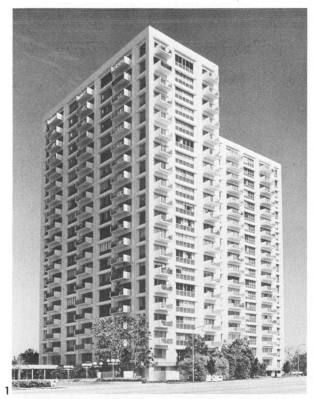

These photos of a light brown building were taken on the same day within a few minutes of each other. Photo No. 1 was taken without a filter; a deep orange filter was used in photo No. 2. Using what you've learned in this chapter, see if you can explain the difference between the two shots.

Infrared

As we've seen, a red filter combined with panchromatic film is the most potent combination in combating image-destroying atmospheric haze. There is, however, an even more effective way of dealing with haze—a special film emulsion that's particularly sensitive to the near-infrared range of the spectrum. Since infrared film possesses the same basic blue (but not green) sensitivity of a normal panchromatic emulsion, it will deliver similar results except for the lack of sensitivity to green objects. When used unfiltered, the film has no special qualities to recommend it over other emulsions.

But fit a red No. 25 filter over the lens and much of the blue and violet wavelengths will be absorbed. This allows little more than infrared wavelengths or radiation (which offer maximum penetration of atmospheric haze) to reach the film. There are many different densities of red filters which will work with infrared film. A No. 87, No. 87C, No. 88A, No. 88C or No. 89B filter allows only infrared radiation to reach the film. While these filters are visually opaque, they will render maximum detail in distant scenics.

Selecting the appropriate red filter for use in infrared photography depends upon the exact effect desired. Any one of those listed above will work satisfactorily, but the No. 25 is probably the best compromise for most landscape/scenic work. It has two important characteristics which the others lack. The No. 25 is the only red filter which permits you to use the maximum ASA-E.I. with black-and-white infrared film, and it's the only one which allows you to focus and compose your picture with the filter in place over the lens. The other red filters mentioned above are so dense that viewing through them with the eye is not possible. If one of these is to be used, you must focus and compose the picture before installing the filter over the lens. If a red filter is not available, keep in mind that an orange one will give similar results with infrared film, although the effect will not be as strong.

Exposure determination is one of the major problems you'll face in infrared photography. Infrared rays are not emitted from a given subject in proportion to the amount of visible light present; thus it is not possible to calculate a correct exposure with a light meter. Any film speed rating you encounter for use with infra-red film is little more than an approximation or hopeful starting point for test exposures. However, the amount of infrared radiation appears to remain more or less the same throughout the day, as well as from day to day during the year. This means that you can bracket a series of test exposures with a given subject and use the results to make an educated guess in the future as to the correct exposure for similar subjects. Believe it or not, this method gives better than average accuracy in exposure determination.

When using a No. 25 filter on a sunny day, start with 1/30 second at f/11 as your basic setting and bracket a series of exposures at half-stop intervals in each direction. If the sky is overcast, try a basic setting of 1/8 second at f/8, although distant scenes will require somewhat less exposure. If you use a No. 87 or No. 88A filter instead of the No. 25, start with 1/30 second at f/8 in sunny weather and 1/8 at f/5.6 un-

Glenn Cooper combined the drama of infrared film with the creative use of a full-frame fisheye to record this scene.

der dull or overcast conditions. With a No. 87C, shoot at 1/30 at f/4.5 in sunlight and ⅛ at f/2.8 when overcast. To ensure the best definition, use the smallest aperture possible consistent with lighting conditions.

A second problem you'll encounter in infrared photography concerns focusing. Infrared wavelengths do not come to a focus at the same point as visible light rays; their plane of focus is slightly farther than that of visible light. To compensate for this shift in focus, most lenses in use today have a special reference mark on the lens barrel for focusing when using infrared film. This mark will take the form of a red dot or line located near the depth-of-field index scale. To use it, focus the image sharply and note the footage setting. Then turn the focusing ring until that setting is aligned with the red dot or line. If your lens does not have this corrective setting, stop it down as much as possible to minimize any effect of the difference in focus. Generally speaking, no such adjustment is necessary when using a 50mm lens stopped down to f/8 or smaller.

To take pictures in the dark with infrared film, fit your flash unit with a No. 87, No. 87C or No. 88A gelatin filter. Rate the film at ASA-E.I. 20 and reduce the flash guide number by one-half. When the flash unit is triggered, the filter will re-

Infrared rays focus at a point slightly farther than visible light. Most modern lenses have an infrared reference line on the barrel (circle).

move all visible light; if anything, only a deep purple glow would momentarily be seen by those looking directly at the flashtube when it went off. In the good old days of flash bulb photography, specially coated bulbs (designated 5R or 25R) were available for use with infrared film. As of this writing, these can still be obtained by your dealer on special order from General Electric, but be prepared to buy the several dozen minimum order. It's worth noting that Sunpak and a few other electronic flash manufacturers have now started to offer electronic flash units which are specifically designed for use with infrared film without a filter over the lens or flash. Unfortunately, these limited-use flash units are quite expensive.

Since infrared film used with a red filter does not receive visible light rays during exposure, you should be prepared for considerable changes in your subject. In some cases, the change may be so great that the haze penetration feature of this combination becomes less attractive than other alternatives, especially if there are people in your picture.

Under ideal conditions, the sky will turn black. Shadows will go very dark, but they generally hold sufficient detail. Grass, bushes and other foliage will turn very light, almost as if they were covered by snow. The results can be most striking, as long as a realistic representation of the subject is not necessary. If you're not particularly fond of such a surrealistic treatment and are more interested in black skies than white grass, try to frame your subject to eliminate or at least minimize any grass or foliage. On the other hand, the extremes in contrast offer an opportunity in creatively handling the subject to make the most of the treatment afforded by the use of infrared film.

Unfortunately skin tones do not fare as well, especially when a woman is involved. They tend to go translucent when photographed with infrared film, giving the subject a sallow, ghostly appearance. To further complicate matters, the effect is not uniform, which adds to the eerie appearance of your subject. If you're trying to convince your friends that they aren't well, photograph them with infrared film and a red filter—they'll certainly wonder what happened.

Infrared radiation can often be used in copy

work to decipher writing on fire-damaged or charred documents, or to detect forgeries and falsified entries. In most cases, the appropriate red filter to be used is best determined by experimentation, but a No. 87 is a good starting point, followed by a No. 87C. Tungsten lamps or photofloods are best suited for infrared copy illumination.

Kodak Ektachrome Infrared film is the only infrared color emulsion available, but this false-color film offers both abstract and unusual results. Unlike normal color films, it doesn't try to deliver an accurate color rendering of a scene even though it's sensitive to both infrared radiation and visible light.

The film is designed to differentiate between objects that reflect infrared wavelengths and those that don't. Originally used for aerial photography and scientific purposes, this type of color film has become very popular with both amateur and professional photographers because of the strange, often surrealistic properties with which it is imbued when used with black-and-white contrast filters.

When infrared color film is exposed without a filter, it shows a strong propensity toward blue, but an entire range of strange and unusual effects can be created simply by photographing your subject through a yellow, green, orange or red contrast filter. For example, Kodak recommends the use of a No. 12 or No. 15 yellow filter. This will turn green grass and foliage red, red flowers become yellow, blacks often change into reds, and skin tones take on a sickly green cast, yet a blue sky remains blue.

Switch to a green filter and foliage turns or-

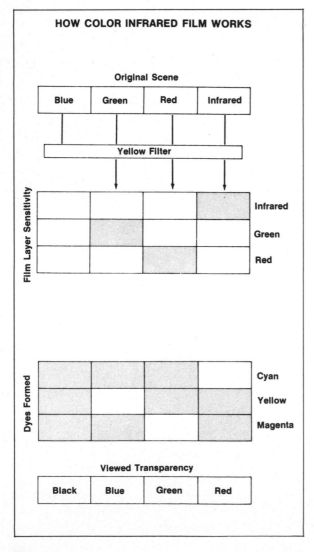

Above left:
The Sunpak Nocto 400 has a specially balanced flashtube and integral infrared filtration for infrared flash photography.

Above right:
Infrared radiation such as that provided by the Sunpak Nocto 400 can be used to decipher writing on fire-damaged, stained, or charred documents.

ange/red with other colors shifting toward magenta. A red filter produces similar orange foliage, but adds green skies with yellow clouds. Use a polarizing filter at the same time and you increase the saturation of all the colors in the picture. Obviously, experimentation is the name of the game, and you can never be absolutely certain exactly what you're going to get. Like black-and-white infrared emulsions, nothing happens on rainy, extremely cloudy or overcast days, and I've even had wishy-washy effects result on bright sunny days. Since everything depends upon wavelengths you can't see, all you can do is cross your fingers and shoot.

As with black-and-white infrared film, exposure meter readings are little more than a starting point, because the ratio of infrared radiation to visible light varies, and the meter can only give you part of the picture. Kodak recommends an ASA-E.I. rating of 100 in daylight when using a No. 12 or No. 15 filter. This gives a basic exposure for front-lighted subjects of 1/125 second at f/16 in bright sunlight. Bracketing your exposures is recommended if it's important to hit the exposure on the button.

I drop the E.I. to 50 when using an orange or red filter, and again to 20 with a green one. If you expose under artificial illumination, photolamps are suggested as the most appropriate

Below left:
Infrared flash can also be used in daylight. This subject was photographed on normal film.

Below center:
Note the the changes when infrared film is substituted. Another source of infrared radiation is obviously necessary.

Below right:
Add the Sunpak Nocto 400 and note the resulting difference between the infrared and straight shots. (Photo sequence courtesy of Sunpak Division, Berkey Marketing Companies)

light source. Rate the film at 50 with a No. 12 or No. 15 filter and add a CC50C-2 color-compensating filter. Incidentally, no focus correction is necessary when using infrared color film.

What subjects are appropriate for infrared color film? Obviously, it's not really suitable for portraits of people, unless you want them to assume an unholy, ghoulish appearance—which might not be a bad idea for Halloween pictures. To give this a try, either filter the lens or the flash and let your camera's auto exposure system do the calculation based on an ASA-E.I. rating of 50.

The effects of infrared color film are most striking when your subject has a large point of interest, such as an old house which retains its normal appearance while surrounded by offbeat foliage and sky renditions. By combining the normal with the unusual in this way, a visual contrast is provided within the picture which is most striking to the eye. When subjects like a waterfall surrounded by foliage are photographed with infrared color film, the results are often quite similar to those you'd get by using a "pop" color filter with normal color film. When this happens, you have not really taken full advantage of the film's unique properties.

Another interesting possibility lies in combining the use of infrared color with a laser or diffraction filter in addition to the contrast filter, or by using a prism lens at the same time. Experimentation is really the key to working with infrared color, and some interesting effects can be obtained in this way. Since you can't tell what you're going to get in advance, it makes things all the more interesting. Don't be afraid to try the offbeat, such as using a dual or tri-color filter with the film. With a properly chosen subject and the filter correctly positioned, the results can be spectacular—and that's why you're using filters, right?

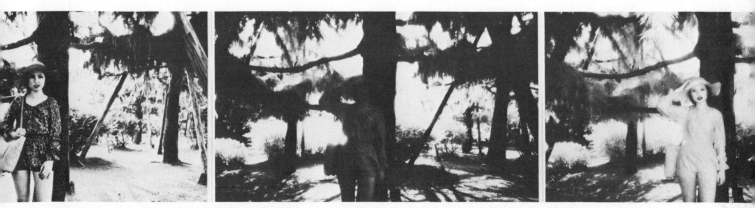

Polarizers

At one time or another, most of us have tried to read something written on a blackboard, only to be frustrated by what we call "glare." Actually, this glare is a phenomenon known as "polarization" and it works something like this. Light travels in the form of electromagnetic radiation or waves. These light waves do not travel perfectly straight, as do the arrows used to represent them in drawings such as we've included here. Instead, light waves tend to vibrate or oscillate in all directions and at right angles to their path.

But pass the light waves through certain substances such as glass or water, or reflect them from nonmetallic surfaces, and many of the multidirectional oscillations will be absorbed. The rays which pass through or are reflected now oscillate only in one direction. Such light rays are said to be "polarized" and tend to create a strong glare or reflection. This is why you can't see the writing on a blackboard at an angle of 30-40 degrees off-center. In addition to the glare and/or reflection which they cause, polarized light rays reduce color saturation in objects which reflect them.

We can eliminate much of the effect of polarized light in photography by using a polarizing filter. Neutral gray in color, a polarizing filter works much like a pair of Venetian blinds. When the two blinds are aligned in the same direction, polarized light will be passed through the open slits. But rotate one blind until it is at right angles to the other and the polarized light rays will be prevented from passing. Nonpolarized light will pass through regardless of how the blinds are arranged, but by rotating the two blinds relative to each other, you can control the amount of polarized light allowed to pass.

Polarizing filters designed for use with SLR cameras are two-piece units. The outer ring is threaded to screw into the camera's lens barrel. The inner ring contains the filter and revolves within the outer ring. Those for non-SLR cameras are simply a disk which fits into an adapter ring for placement over the camera lens.

Once a two-piece polarizing filter is attached to your camera lens, you simply look through your SLR's viewfinder and rotate the filter until you see the desired effect. As you turn the filter, watch the sky—it will gradually darken to a point, then turn light again as rotation exceeds 180 degrees. To use the disk/adapter-ring type, you simply hold it in your hand and look through it at the subject as you slowly rotate the filter. When you see the effect you want, transfer it to the camera lens without changing its relative position to the subject and you're ready to take advantage of its effect.

The effect, incidentally, will change as you change camera or subject position. The maximum glare/reflection reduction with a polarizing filter takes place when you're shooting at a

When conditions are correct, a polarizer will produce a near-black sky in black-and-white, or a deep blue in color, without changing other tonal values.

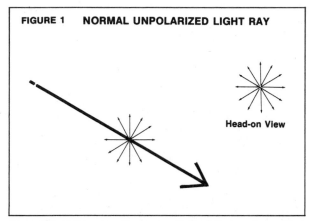

FIGURE 1 NORMAL UNPOLARIZED LIGHT RAY

Head-on View

Normally light rays vibrate in all directions perpendicular to their direction of travel.

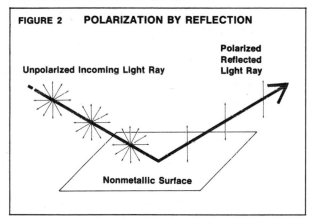

FIGURE 2 POLARIZATION BY REFLECTION

Polarized Reflected Light Ray

Unpolarized Incoming Light Ray

Nonmetallic Surface

If a light ray hits a nonmetallic surface, the vibrations in only one plane are reflected completely —the light ray is said to be polarized.

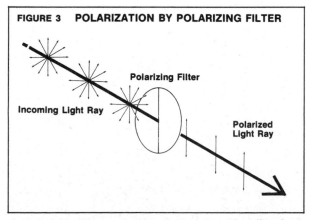

FIGURE 3 POLARIZATION BY POLARIZING FILTER

Polarizing Filter

Incoming Light Ray

Polarized Light Ray

A polarizing filter polarizes light; it permits vibrations in only one plane to pass.

30-to-40-degree angle to the surface. If you cannot achieve the effect you want, or if the effect is only partial, change your position relative to the subject slightly and try again. You should be aware that there are times when a partial correction is all that a polarizing filter will give you. Regardless of where or how you change the camera-subject position, some glare or reflections may remain. In such cases, there's nothing wrong with the camera, your subject or the filter—it's just the nature of the light rays.

A polarizing filter is extremely versatile, as it can be used equally well with either black-and-white or color film. It's the only filter which will deepen a blue sky in a color shot without changing the other colors in the picture. With black-and-white film, it will darken the sky without altering other tonal qualities. To assure the maximum effect when photographing the sky (whether in color or black-and-white), you should be at a right angle to the sun. This means that the effect will be greater in mid-morning or midafternoon than at high noon, and that sidelighted subjects will benefit more than front or backlighted ones. In addition to controlling sky density/saturation, the polarizing filter will increase color saturation, tone down skin reflections, and penetrate light haze; it is also particularly useful in controlling reflections and glare when copying.

Beginners are often confused about exposure compensation with a polarizing filter because of the way in which the filter works. As you rotate a polarizing filter, the sky will grow darker in your viewfinder. Despite what some novices think, this does not mean that you need to increase your exposure according to the relative density of the sky.

A polarizing filter is a neutral density filter, and as such, has a built-in filter factor. This factor is usually 2.5X or 3X depending upon your particular filter and manufacturer, and it remains constant regardless of the filter's position. Whenever a polarizing filter is used, your exposure should be increased between 1⅓ and 1½ stops—that's it.

There are a few minor exceptions to this statement, but they exist because of the nature of the particular subject, not because of the filter. When a meter reading is taken of a scene full of reflections, and then the reflections are

removed, the scene will appear darker than expected. If you encounter many such subjects, you can eliminate any mental exposure juggling by using an incident-light meter, or by taking a reflected-light reading from an 18-percent-reflectance gray card.

When using an SLR with a built-in metering system, take your reading with the filter off the camera. Apply the filter factor to the reading and set the camera's controls; then install the polarizing filter and adjust it for the effect you want. As with contrast/correction filters, the camera's metering system will theoretically compensate for the polarizing filter's factor, but some camera meters will give erroneous readings when used this way.

This is particularly true of cameras which use a half or split-mirror to direct light to the built-in meter cell. Such beam-splitters may polarize the light, preventing the transmission of much of that polarized in a given direction. Some Canons, the Leica M5, all Prakticas and Topcon D, DM and Super D cameras use this type of system. If you own such a camera, consider the Hoya PL-CIR or circular polarizing filter. This is much like a linear polarizer but has a special wave retardation plate to produce light which vibrates in spirals instead of a single plane. This avoids any possible errors caused by the polarizing effect of light due to fixed mirrors or beam-splitter in the camera's metering system.

So much has been made of the polarizing filter's ability to reduce glare and darken blue skies that many photographers tend to overlook

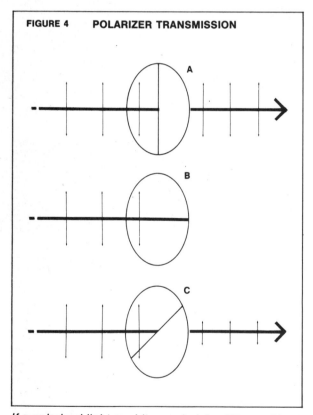

FIGURE 4 POLARIZER TRANSMISSION

If a polarized light ray hits a polarizing filter and is vibrating in the plane the filter lets pass, it will be transmitted by the filter (A). If the light ray is vibrating perpendicular to the plane of vibrations the filter will pass, the light ray will not be transmitted by the filter. This is what happens when a polarizing filter eliminates a reflection of polarized light (B). If the polarized light ray is vibrating at an angle to the plane that the filter will pass, a portion of the light ray will be transmitted by the filter, and the reflection will be partially eliminated (C).

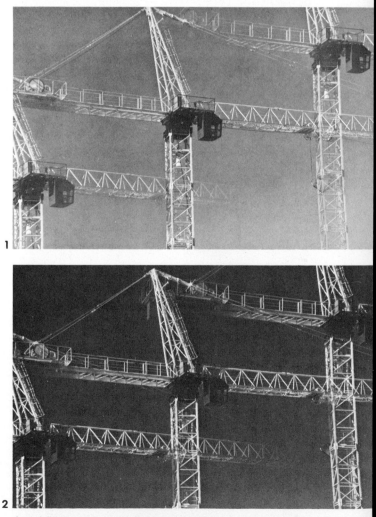

A red filter may not sufficiently darken the sky (photo No. 1). Add a polarizer to the red filter and the change in sky tone is dramatic (photo No. 2).

its other values, many of which apply equally to color and black-and-white film. For example, it will effectively cut through haze to sharply define distant objects and increase the vividness of any colors involved. It does this by reducing the polarization of light rays which are reflected on vapor particles in the atmosphere.

Since the polarizing filter works in a different manner from a contrast filter in reducing haze, it follows that the effect gained by combining the two will greatly exceed the effect of either one when used alone. Under many circumstances, the use of a deep green filter with the polarizing filter will give a pseudo-infrared effect to sky tones, but without the radical alteration in foliage tones. Combine a red and polarizing filter for dramatic black skies and a pseudo-night effect. The yellow and polarizing filter combination also produces a dramatic sky, but one not as pronounced as with the red filter.

Combining contrast filters with the use of a polarizing filter can make it difficult to focus and

compose through the viewfinder, especially where a deep green or red filter is involved. For this reason, always attach the polarizing filter to the lens first, then add the other filter. If you find it difficult to work with the two, you can remove the contrast filter while you focus, compose and adjust the polarizing filter, then replace the contrast filter before making your exposure.

The polarizing filter has another handy use which many photographers overlook. If you're shooting a subject under a bright blue sky and there's a wide expanse of green grass or other foliage in the picture, you can expect the green to take on a slightly bluish tint as a result. Now, most of us would automatically reach for a skylight 1A or UV filter in this case, but a polarizing filter used instead will deliver far clearer tones and much more vivid colors. This attribute makes it a valuable tool in preventing or eliminating color distortion.

When it comes to photographing subjects through store windows without interference from glare, you should remember color correction. Since a good deal of your attention will be devoted to cleaning up the reflections, it's easy to overlook the fact that the color temperature

Polarizers are useful for reducing/eliminating glare and reflections, as shown in these before/after shots by David Neibel.

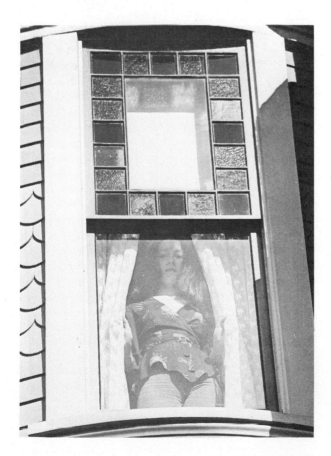 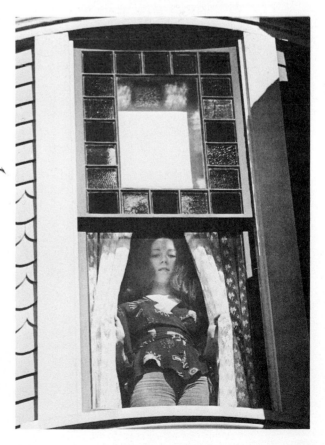

1

2

of the lighting on the subject may very well be different from that in front of the glass where you're standing. When this is the case, it calls for the use of a color correction filter as well as the polarizing filter.

If you've ever tried copying a document, glossy photo or oil painting, you know how difficult it can be to properly light the subject without encountering glare or reflections. One solution is to fit a polarizing filter over the camera lens; another is to use polarizers over your lights. The best method, of course, is to use both. In this way, you can eliminate virtually all hot spots and reflections. Since exposure can be tricky with this arrangement, I suggest that you rotate the filters on the lights to their desired position, then take a meter reading through the camera filter and bracket a series of five pictures at half-stop intervals.

Because of its ring-within-a-ring design, the standard polarizing filter is somewhat thicker than other photographic filters. Under some circumstances, this can lead to problems with vignetting when the polarizing filter is used with wide-angle lenses, especially the newer compact designs. To prevent such vignetting at wide apertures, Tiffen manufactures a special thin polarizer. Other than its thickness, there is no difference in its use. If you're interested in wide-angle photography, consider one of these instead of the regular polarizing filter.

Another useful variation is the Hoya Pol-Fader. This combines two polarizing filters in independent rotating rings. Rotating the rings in the same direction will produce the usual polarizing filter effect, but rotating them in opposite directions gradually closes off almost all of the light reaching the film. These are favored by cine enthusiasts to produce a smooth fade-out at the close of one sequence and a fade-in at the beginning of the next.

A polarizing filter is useful with virtually all subjects photographed in daylight. Don't keep it in your gadget bag just because the sun is not shining—polarized light abounds on hazy and overcast days, as do unwanted color casts. The polarizer will not eliminate glare on metal objects, because metallic surfaces do not polarize light. In such cases, you'll have to change your camera or subject position to get rid of such distractions.

Left:
There may be times when glare reduction is not desirable, as shown in this comparison. The glare on the water in photo No.1 helps to pop the birds out in sharper relief and actually enhances the picture.

Consider combining the polarizing filter with various other special-effect filters. Some of them, as we'll see, actually depend upon the use of a polarizer to produce their particular effect. But others, like the mirage prisms, cross screens and star filters, do not; and since these require no exposure compensation for their use, they make ideal combinations for use with some subjects. You might even try combining the polarizing filter with a laser or diffraction filter and color film. The options are wide open for combining a polarizing filter with others, so experiment as much as possible. Many subjects may not respond that well with some combinations, but when you hit on one that does, the effect can be spectacular.

DETERMINING MAXIMUM POLARIZATION

There are circumstances when determining maximum polarization visually through your viewfinder can be difficult, especially if the filter's effect is not overly dramatic. Rotating the polarizer back and forth to arrive at the exact point of maximum effect can be as frustrating as trying to focus a wide-angle lens on a particular point in a landscape.

If your camera has a built-in meter and uses a needle readout instead of the newer LED display, here's an easy way to determine when the polarizer is oriented at its point of maximum effect. Supose the readout when you look through your viewfinder (with the polarizer in place) is 1/125 (aperture-preferred) or f/8 (shutter-preferred). Rotate the polarizer slowly until the needle begins to move toward a slower shutter speed or larger aperture. Continue rotating it until the needle begins to reverse its direction. The point of maximum effect is that position *just before* the needle reversal takes place.

The same technique can be used with match-needle viewfinders that have no numerical display. The needle will move toward the + or overexposure position as the effect increases. At the point just before the needle reverses and starts back toward the center, you have reached maximum effect.

Neutral Density Filters

Dark gray in color, neutral density (ND) filters are used for exposure control with black-and-white or color films. Since these filters absorb all colors of the visible spectrum equally, they reduce the amount of light passing through them to the film. Their only use is to permit the photographer to work with wider lens openings or longer exposures. ND filters work without affecting image tone, control or color balance, but they do absorb ultraviolet wavelengths. This makes the use of a haze, UV or skylight filter unnecessary whenever a neutral density filter is used over the lens.

Many manufacturers offer neutral density filters, which are primarily colloidal carbon and dyes uniformly dispersed in either gelatin or optical glass. They are generally available in strengths designated as 2X, 4X and 8X. These require one, two and three stops, respectively, increased exposure. However, Tiffen manufactures a 15-step density range in glass filters, and Kodak offers 13 densities in filter gels, as shown in Table 1.

The logarithmic numbering system used by Tiffen and Kodak means that each .3 increase in density equals a one-stop exposure increase. By referring to Table 1, we see that the ND filters with a factor of 2X, 4X and 8X are designated as .3, .6 and .9, respectively. Thus, a 2X ND filter is the same as a Tiffen .3, the 4X a Tiffen .6, and the 8X a .9.

Neutral density filters are usually used alone, but when you need a reduction in light transmission greater than one ND filter can provide, it's possible to combine two or more to achieve the necessary effect. A simple way of calculating exposure when using more than one ND filter is to multiply the factors. Let's suppose you have a 2X and a 4X ND filter, but need a three-stop reduction. Since the 2X requires a one-stop increase and the 4X an extra two stops (2X x 4X = 8X), the two used together will add up to a three-stop exposure increase, or just what you need.

Neutral density filters have five possible uses in exposure control.

1. They will reduce exposure under bright lighting conditions when the camera lens will not stop down sufficiently, or when the film used is too fast for the camera's exposure range. For example, suppose that you've got ASA-E.I. 400 film in your camera, or it's the only film you have with you. Your light meter tells you that the proper exposure is 1/1000 second at f/16, but your camera has a top speed of 1/500 second, and the lens only stops down to f/16. Shooting under these conditions, you'll overexpose by at least one stop—more if the primary subject is lighter than the rest of the scene. A 2X ND filter will bring the situation under control; a 4X ND will give you an extra stop option.

2. ND filters let you shoot at one given aperture under a variety of lighting conditions. If it's important to retain the use of a particular aper-

By reducing the amount of skylight reaching the film, graduated neutral density filter brings out sky tones.

ture for pictures under different light intensities, use the appropriate ND filter to retain exposure control. This would be useful when you're shooting pictures of a subject with a diffusion filter under more than one lighting setup. To retain the correct amount of diffusion from shot to shot, you would want to use the same aperture, which might not be possible to 'control with shutter speed alone.

3. Neutral density filters allow you to reduce the shutter speed for special effects. With a series of these, you can achieve an extended range of motion effects, such as the ''explosion'' technique with a zoom lens, when normal outdoor exposure required would be too small to permit the use of a satisfactorily slow speed.

There are other applications for this technique. One is to add blur to racing photos taken with fast film in bright sunlight. Another is to increase the exposure sufficiently to record a busy place as being empty. Suppose you wish to photograph an intersection, but without the normal flow of people who pass through it. Use an exposure of several minutes and those passing in front of the camera will not even appear

Between pedestrians and traffic, photographing a street scene can be frustrating (photo No. 1). Use ND filters to lengthen the exposure from seconds to minutes and objects passing in front of the lens will not be recorded on the film (photo No. 2). Of course, there'll always be someone who'll take up a stationary position in your field of view.

on your negative. You might have to interrupt such an exposure if someone thoughtlessly stands in your field of view for any length of time. A continuous or near-constant traffic flow will also record as a blur, yet this might be in line with your desired interpretation of such a scene.

The creative uses of ND filters in this instance are endless—how about using a wide-angle lens at the beach and capturing the path of the sun through your scene? A 4.0 ND filter will do the

TABLE 1

NEUTRAL DENSITY FILTERS

Filter Type				
Tiffen	Kodak Wratten	% Light Transmission	Filter Factor	F-Stop Increase
.1	.1	80	1X	½
.2	.2	63	1.5X	¾
.3	.3	50	2X	1
.4	.4	40	2.5X	1¼
.5	.5	32	3X	1⅔
.6	.6	25	4X	2
.7	.7	20	5X	2½
.8	.8	16	6X	2¾
.9	.9	13	8X	3
1.0	1.0	10	10X	3½
1.2	–	6.3	16X	4
1.5	–	3.2	32X	5
2.0	2.0	1.0	100X	6⅔
3.0	3.0	.1	1000X	10
4.0*	4.0	.01	10,000X	13⅓

*Can be used when Solar Filter is specified.

1

2

trick, requiring a practical exposure of about six hours at f/5.6 or 12 hours at f/8 with ASA 100 film. For those who immediately calculate this suggested exposure as incorrect according to the filter factor, remember that we're talking about a *long* exposure. This means reciprocity failure in most cases, which explains the difference between my "practical" exposure and the theoretical one.

4. ND filters permit the use of large apertures in portraiture when selective focusing is desirable. They're especially useful when working outdoors. Suppose you're photographing a pretty girl against a cluttered background. Re-arranging the subject to change background is one possiblity, but it may not be satisfactory because the change in lighting destroys the effect you want. So there's no other choice of background—you're stuck with the clutter. To make matters worse, the proper exposure with your highest shutter speed will still provide enough depth of field to keep the background sharp. But a 4X or 8X ND filter will reduce the amount of light sufficiently to require the use of a large aperture, giving you sufficient depth of field to keep your subject sharp, but throwing the background into a nice blur which breaks up the pattern and accentuates her instead of detracting.

5. Neutral density filters are a good means of controlling exposure when your electronic flash (EF) is very powerful, or very close to your subject. A given EF-film combination used at a short flash-to-subject distance can result in overexposure. Unless the EF can be detached from the camera and moved farther away, the ND filter is the best way to reduce the amount of light reaching the film. Simply calculate the correct exposure and determine how many stops you must reduce your exposure; then select the appropriate ND filter. You can use the filter over the lens or you can tape a gel across the flashtube.

Automatic electronic flash (AEF) units use a sensor to determine the proper amount of light for a correct exposure. These function fine within the flash range specified by the manufacturer

ND filters are useful in background control. When the lighting is sufficiently bright to require a small lens opening (photo No. 1), use an 8X ND filter. Opening up the aperture to compensate will throw the background out of focus (No. 2). Photos by Bill Hurter.

1

2

for a given film/f-stop combination, but most do not work properly at close flash-to-subject distances. Such close distances result in a flash of extremely brief duration, which can lead to reciprocity failure with some color films. To solve this problem, fit an ND filter over the flashtube—but make sure it does not cover the sensor. This will reduce the intensity of the light reaching the sensor, which will not cut off the flash as quickly. The result is a longer duration flash which will not cause reciprocity problems.

You can also use a neutral density filter over the lens when you want to work at a larger lens opening than the AEF-film combination requires. Suppose the AEF-film combination in use requires that the lens be set at f/11 for a correct exposure. But you want to shoot at f/4, so simply place an 8X (.9) ND filter on the lens. The AEF sensor measures the flash as if the lens were set at f/11, but the filter absorbs that extra three stops of light reflected from your subject.

In addition to the wide range of neutral density filters which we've already discussed, there's also a special graduated clear-to-neutral density filter available. Sometimes called a sky con-

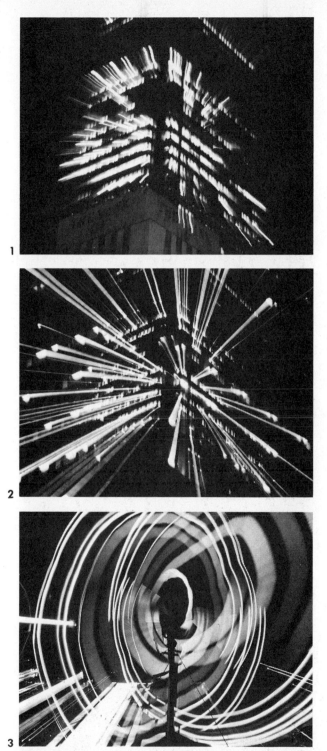

1

2

3

Zoom effects can also benefit from the use of an ND filter. The correct exposure may not be long enough to create a full-blown effect (photo No. 1). ND filters will lengthen the exposure and provide time to create a more complete effect (photo No. 2). Using a couple of ND filters will lengthen the exposure sufficiently to let you experiment (photo No. 3).

TABLE 2

SELECTIVE FOCUS EXPOSURE CONTROL

And you wish to use this f-stop:	When correct exposure requires this f-stop:				
	f/8	f/11	f/16	f/22	f/32
	Use this ND filter or combination:				
1.4	1.5	1.8	2.1*	2.4*	2.7*
2	1.2	1.5	1.8*	2.1*	2.4*
2.8	.9	1.2	1.5	1.8*	2.1*
4	.6	.9	1.2	1.5	1.8*
5.6	.3	.6	.9	1.2	1.5

*Use two or more ND filters to equal the specified density.

TABLE 3

FILM/SHUTTER SPEED EXPOSURE CONTROL

And the smallest marked f-stop on lens is:	When correct exposure requires this f-stop:							
	f/22	f/32	f/45	f/64	f/90	f/128	f/180	f/256
	Use this ND filter or combination:							
16	.3	.6	.9	1.2	1.5	1.8*	2.1*	2.4*
22		.3	.6	.9	1.2	1.5	1.8*	2.1*
32			.3	.6	.9	1.2	1.5	1.8*
45				.3	.6	.9	1.2	1.5
64					.3	.6	.9	1.2

*Use two or more ND filters to equal the specified density.

trol filter, this amounts to half an ND filter and half clear optical glass. The two portions are blended together with a feathered edge to provide a gradual transition between the sky and the foreground.

When would you use one of these? There are several possibilities, one of which is a landscape in which the foreground is on the dark side, but the background includes a bright sky. In such a case, there might be as much as five f-stops' difference between the correct exposure for the two, or considerably more than the film's latitude could compensate for.

By fitting a graduated neutral density filter to the camera so that the clear area covers the foreground, the ND portion will act on the background. In this way, it reduces the brightness of the sky without affecting the foreground. This allows an exposure that will give a satisfactory rendition of both areas in the picture without resorting to such darkroom controls as dodging or burning-in.

Another possible use for this filter comes when you want to darken the sky, but do not want the tonal value change which accompanies the use of a contrast filter. It can be a great help in overall sky darkening in color photography, and is the only effective way in which you can darken an overcast sky with black-and-white film. When working indoors, the filter can be used to subdue background lights or other bright areas.

As with other split-field filters, you must pay attention to the composition of the picture. The neutral density part of the filter should parallel the horizon without including any vertical lines such as trees or telephone poles. When such verticals extend from one part of the filter to the other, they will be divided into light and dark sections. When there is a subject of interest within the foreground, try to use a high enough camera angle to prevent the horizon line from intersecting it.

A proper exposure when using the graduated neutral density filter should include only the foreground. Although the filter does not require an exposure increase, it's not a good idea to meter through the camera's lens with it in place—you may end up overexposing the foreground. The best method is to take your reading and set the camera, then fit the filter in place and expose. Like standard ND filters, these come in different strengths.

Should it be desirable to use a contrast filter with black-and-white film to bring out clouds, etc., it can be used in conjunction with the neutral density filter. Thus, if you need a three-stop reduction, you can use a 2X yellow filter and a 4X ND filter to achieve the same exposure reduction as you'd get with an 8X ND or a 2X and 4X combination. Amateur photographers tend to overlook the value of a neutral density filter, but it can be one of your most creative tools.

Focusing an SLR fitted with an ND filter may be somewhat difficult, especially if you're using either the 4X or 8X densities. Although they reduce light no more than two or three stops,

ND filters are particularly useful in reducing the intense light found in beach and snow scenes, especially when the camera is loaded with fast film.

viewing through them is different from viewing through an orange or red filter with the same factors. The contrast filters absorb only certain wavelengths instead of all light rays. This slight handicap, however, should not prevent you from taking advantage of the unique uses of neutral density filters.

Determine how many ND filters you'll need to use for the picture (hopefully, only one); then fit that number of light-colored filters to your camera lens. It doesn't matter what they are—skylight, haze, color compensating, etc.—their only purpose here is to compensate for any focus shift that might result from the use of the neutral density filters. Once you've set the focus according to your composition, remove them and replace with the necessary ND filter(s) to take your picture. Be sure to calculate the correct amount of exposure increase and adjust the camera accordingly.

NIGHT PHOTOGRAPHY AND NEUTRAL DENSITY FILTERS

Use a neutral density filter at night? It may be necessary when working with special-effect filters to reduce the exposure sufficiently to permit the use of a particular aperture or shutter speed. For example, let's suppose that you're working with ASA 125 black-and-white film. The subject is a multiple-fixture lamp pole and you want to revolve the prism attachment during exposure to create the effect shown here. Because of the subject's brightness level, basic exposure is one second at f/16. Revolving the prism attachment smoothly during a one-second exposure is difficult, but add a 4X ND filter and you've increased the required exposure from one to four seconds. That extra three seconds will make it far easier to obtain the exact effect you're seeking. In short, don't fall into the trap of regarding ND filters as useful only in bright sun—with a little thought, you'll be surprised at how many uses you can devise for them.

THE SOLAR FILTER

You're probably aware that you should *never* view the sun directly with your naked eye or through a camera lens. If it happens to enter the edge of your composition when using a normal, wide-angle or moderate telephoto (to 135mm), there's nothing to worry about, as long as you don't fix your gaze in that direction for very long. The problem arises when using long tele lens to produce those big ball-of-fire sunsets, or when attempting to photograph a solar eclipse. That flock of geese flying across a bright solar disc certainly makes an exciting photo, but such shots are hazardous to your vision.

In cases like this, we are told to use a "solar filter," but the problem is that very few photo shops know what it is. Most dealers will simply shrug their shoulder and tell you they never heard of such a beast. The only manufacturer who produces a filter by that name is Celestron International, 2835 Columbia Street, Torrance, CA 90503. The Celestron Solar Filter is designed to press-fit over the front of a Celestron mirror telephoto. It's actually an optically flat window coated with Inconel®, a neutral density substrate that reduces the intensity of the sun's rays to 1/100 of one percent at all wavelengths.

For photography with other lenses, you can use a 4.0 neutral density filter available from Tiffen or Kodak—see Table 1. The 4.0 ND filter has a factor of 10,000X and requires a 13⅓ f-stop increase in exposure. This filter is so dark that you cannot see through the viewfinder under ordinary illumination levels.

Corrective Filters for Color Photography

When you take note of the world around you, you quickly notice that familiar objects change color somewhat according to the type and level of ambient light which illuminates them. A young lady sitting across the table from you looks far warmer and more romantic by candlelight than she would if the room were illuminated by fluorescent lighting. Restaurants that deal in atmosphere as well as food know this and try to accent the effect. As we've pointed out earlier, the human eye and brain have the remarkable ability to accommodate such changes and accept them as visually normal without a second thought.

Color films do not have this accommodation ability. They are balanced for a particular mixture of the red, green and blue wavelengths which compose white light. Daylight films have a color sensitivity which is balanced to respond most accurately to what we call average daylight—a mixture of skylight and sunlight found in middle latitudes at noon on a bright summer day. Any other mixture of light will cause a deviation from the color norm of the film. This explains why daylight color films will show a bluish cast when they are exposed under dull lighting conditions, and a reddish cast if exposed at early morning or later in the afternoon.

Tungsten or indoor films are balanced more on the reddish side to respond to the increased red content of artificial light, as measured by a color temperature scale designated in Kelvin or K units. In the past, tungsten color films have been designated either as Type A or Type B, depending upon the color temperature of the particular artificial light source for which they are balanced—photofloods at 3400°K (Type A) or studio lighting at 3200°K (Type B). Negative color or print emulsions make no such differentiation between daylight and tungsten balance, as correction is made during the printing process.

Color Temperature

The Kelvin color temperature system is used to describe the color of light. Named after Lord Kelvin who formulated it, the Kelvin system is a means of describing the quality of light which contains differing amounts of each color. According to this system, color is measured in Units Kelvin (K) using a scale graduated in increments from 1500 to 20,000. Blue, white and yellow are on the higher end of the scale, with reds having a lower value. Light that is suitable for photography falls within the 2800 to 7500°K range, according to the type and balance of film being used.

Common light sources have been assigned average Kelvin values (see Figure 1), but several factors cause the values to deviate from those assigned. Depending upon who does the rating, daylight has a stated color temperature of between 5500 and 6500°K. But daylight will

FIGURE 1
ASSIGNED COLOR TEMPERATURE VALUES FOR COMMON LIGHT SOURCES

Light Source	Color Temperature Units Kelvin
Clear blue northern skylight	15,000-27,000
Skylight—open shade	10,000-12,000
Skylight—overcast or dull	6500-7000
Electronic flash	6000-6800
Daylight (film balance)	5500-6500
Blue-tinted flash bulb	5500-6000
Sunlight—high noon	5400
Morning/afternoon daylight	5000
Blue-tinted photoflood	4800-5400
Magicube or flashcube	5000
Clear flash bulb	3800-4200
Photoflood lamp (Type A film balance)	3400
Tungsten studio lamp (Type B film balance)	3200
Tungsten halogen lamp (Type B film balance)	3200
250-watt household light bulb	3000
100-watt household light bulb	2900
75-watt household light bulb	2820
40-watt household light bulb	2650

FIGURE 2
CONVERSION FILTERS

When film is balanced for:	And you wish to expose it by:	Use this filter or its equivalent:	Or your pictures will look too:
Daylight	3200°K Light	80A (4X)	Orange
Daylight	3400°K Light	80B (4X)	Orange
Daylight	Aluminum Foil Flash Bulbs	80C (2X)	Orange
Daylight	Zirconium Foil Flash Bulbs	80 D (1X)	Orange
3200°K Light	Daylight	85 B (1.5X)	Blue
3400°K Light	Daylight	85 (1.5X)	Blue

also differ in color temperature according to the time of day, place and the percentage mixture of skylight and sunlight. Artificial light sources such as photoflood bulbs have a stated color temperature of 3400°K, but this is not constant either. The color temperature of a photoflood bulb will change according to voltage fluctuations and how long the bulb has been used—the longer the filament has burned, the lower the color temperature.

For most amateur purposes, the assigned values of light sources are sufficiently close for matching with appropriate color film emulsions. If the occasion demands an accurate neutral color balance, the quality of the light must be determined. This is done with a color temperature meter, which tells us exactly where the light falls on the Kelvin scale. The appropriate filter can then be selected to bring the light and film into proper balance.

Generally speaking, bluish filters will raise the color temperature, while amber or yellowish filters are used to lower it. These filters can be used either on the lens or over the light source. There are three types of such filters used with color films: conversion, light-balancing and decamired.

Conversion Filters

These permit large jumps in color balance correction, such as converting daylight film for use with tungsten illumination, or vice versa. For this reason, their color is quite deep compared to other filters used with color film. Conversion filters are of two types—those that "warm" the light and those that "cool" it down. The amber or yellowish "warming" filters absorb sufficient blue from daylight to convert it to the color temperature of various tungsten light sources, while the bluish "cooling" filters absorb enough yellow to convert tungsten light to daylight film's color temperature.

When a daylight color film is used under artificial illumination without a conversion filter, the picture will contain a deep yellow or reddish cast. If you're using a 3400°K photoflood lamp, an 80B will bring the light into balance with the film. A 3200°K studio lamp, on the other hand, requires the use of an 80A filter. If household lamps are your only light source, the 80A will help, but you'll also need additional correction, which means the use of the light-balancing or decamired filters to be explained shortly. When clear flash bulbs are used, an 80C or 80D will make the necessary conversion.

Using an indoor or tungsten-type color film outdoors in daylight will result in pictures containing a deep bluish cast. An 85 filter will convert Type A film for daylight use, while an 85B is necessary to convert Type B films. Figures 2 and 3 summarize the use of conversion filters according to the film and light conditions.

Light-Balancing Filters

These are designed to make smaller changes in the quality of light reaching the film. Such changes will eliminate undesirable bluish or reddish casts, as when using 3200°K lights with Type A film, or 3400°K lights with Type B. In a technical sense, a light-balancing filter does its job by slightly adjusting the relative amounts of the primary colors that it transmits from the light source to the film. As with the conversion filters, there are two types of light-balancing filters: the 82 series (bluish) which cools, and the 81 series (yellowish) which warms.

Generally speaking, the 82 series will correct the warmth of early morning or late afternoon sunlight. These filters are also useful when you wish to "cool" down the normally warm color rendition produced by some color films. Used indoors, they will reduce the warmth of house-

FIGURE 3			
	FILTERS FOR FLASH		
If you use this type of flash:	For daylight film, use this filter:	For 3400°K film, use this filter:	For 3200°K film, use this filter:
Electronic	None or 81A or 81B	85B*	85B*
Blue flash bulbs	None	85B*	85B*
Zirconium-filled flash bulbs (AG-1, B3, B5)	80D	81C	81C
Aluminum-filled flash bulbs	80C	81C	81C
*These film/flash combinations are not recommended.			

hold bulbs or older photo lamps whose color temperature has changed with age.

The 81 series can be used to offset the coolness of certain photographic situations, such as open shade or overcast conditions which are naturally "cool." These filters also warm up color films which tend to lean toward the cooler color rendition.

In a more pragmatic sense, light-balancing filters will absorb some of the orange found in pictures taken in early morning or late afternoon sunlight with daylight film (No. 82A), and absorb some of the bluish cast caused by cloudy weather or when some electronic flash units are used with daylight film (No. 81A). Tests should be made in the latter case before indiscriminately using the filter, as many late-model EF units have a "gold-tone" flashtube which is designed to correct the light output itself. Light-balancing filters are also useful in balancing clear flash bulbs when used with Type A (3400°K) film.

To determine exactly which light-balancing filter is necessary to produce a "normal" color rendition, you'll need a color temperature meter. These are expensive and vary in their capabilities according to price—the more costly ones will measure all of the primary colors, which allows them to be used with all kinds of light sources. Less-costly color temperature meters measure only the relative amount of red and blue, and can thus be used only with tungsten illumination.

Unless you're a stickler for color consistency or a pro who makes his living from color work, you'll be just as well off shooting two or four different shots with different light-balancing filters and then choosing the one you like best. Don't forget that the light by which you view your slides will influence their color rendition. Hand-held slide viewers are "warmer" than a slide projector, and both are warmer than a transparency light box which relies upon fluorescent tubes for illumination. Try to standardize on one and make future judgments about the use of light-balancing filters with this in mind.

No exposure increase is necessary with the 81, 81A, 81B, 81C, 82 or 82A filters, although you might want to open up about ⅓ stop if exposure is critical under any circumstances, but once more, I'd suggest bracketing as the best solution to the problem. The 81D and 81EF, as well as the 82B and 82C filters, should be given ⅔-stop additional exposure.

Light-balancing filters can also be used in combination to produce stronger effects than a single filter will provide. Be sure to add the increase in f-stops necessary for each filter and open the lens by the total amount. Unfortunately, the results are quite difficult to predict with any degree of accuracy when two or more light-

FIGURE 4

LIGHT BALANCING FILTERS

When film is balanced for:	And you wish to expose it by:	Use this filter or its equivalent:	And increase exposure by:
3200°K Light	3400°K Light	81A	⅓ Stop
3400°K Light	3200°K Light	82A	⅓ Stop

This filter:	Balances this light for 3200°K film:	Balances this light for 3400°K film:	And requires an exposure increase of:*
81	3300°K	3510°K	⅓ Stop
81A	3400°K	3630°K	⅓ Stop
81B	3500°K	3740°K	⅓ Stop
81C	3600°K	3850°K	⅓ Stop
81D	3700°K	3970°K	⅔ Stop
81EF	3800°K	4140°K	⅔ Stop
82	3100°K	3290°K	⅓ Stop
82A	3000°K	3180°K	⅓ Stop
82B	2900°K	3060°K	⅔ Stop
82C	2800°K	2950°K	⅔ Stop
82 + 82C	2720°K	2870°K	1 Stop
82A + 82C	2650°K	2780°K	1 Stop
82B + 82C	2570°K	2700°K	1⅓ Stop
82C + 82C	2490°K	2610°K	1⅓ Stop

*Approximate values—check by practical test for critical work. If used in combination, add the exposure increase for each filter together and open aperture by the total figure.

balancing filters are used. If you become seriously interested in their use, you'll welcome the mired system discussed below.

Decamired Filters

Although conversion and light-balancing filters permit you to make the most commonly needed changes in color temperature of the light striking your film, they depend upon the use of the Kelvin color temperature system. Unfortunately, the Kelvin scale is not linear in nature. This means that a given filter will change color temperature by a different amount depending upon where it is placed on the scale. To give an example of this deficiency (and show why it is a deficiency), let's suppose that you're using a Type A indoor film but wish to take pictures in daylight.

The use of an 85 filter will change the color temperature from 6000°K to 3400°K, or by 2600°K. The same 85 filter, however, will only change tungsten light by about 1000°K, or from 3400°K to about 2400°K. Such great variations make it difficult to apply the Kelvin system to more than a few stated filters and values with any degree of uniformity or certain success.

This problem led to the development of the mired system of color temperature, in which a single number indicates the warming or cooling effect of a particular filter—regardless of where it is placed on the color temperature or mired scale. In this system, each color temperature is given its own number, called a mired value. This is determined by dividing the color temperature in Kelvin units into one million. Using this formula, 3200°K tungsten light has a mired value of 312 (1,000,000 divided by 3200), and daylight (as defined by Kodak) has a mired value of 182 (1,000,000 divided by 5500).

To apply the mired system to our problem, as stated earlier, the difference between 6000°K (170 mireds) and 3400°K (295 mireds) is 125 mireds. The difference between 3400°K (295 mireds) and 2400°K (420 mireds) is also 125 mireds. Thus, any filter or combination of filters which will produce a 125-mired shift will give consistent results—regardless of where it is placed on the scale.

Mireds are small units—the term stands for *micro reciprocal degrees*. Micro represents 1 over 1,000,000, reciprocal means inverting that figure to 1,000,000 over 1, and degrees equals color temperature in degrees; thus one mired equals 1,000,000/color temperature. To obtain numbers that are easier to work with, mired values are usually rounded off and expressed as decamireds, or tens of mireds. Since 10 mireds is the smallest shift generally encountered in photography, decamireds are more convenient to use as an expression of measurement. For this reason, tungsten light's mired value of 312 becomes a decamired value of 31, and daylight's mired value of 182 becomes a decamired value of 18.

Decamired (DM) filters come in warming (R for reddish) and cooling (B for bluish) filters. Both R and B filters have decamired values of 1½, 3, 6 and 12. A No. 3 (red or blue) decamired filter will cause a color temperature shift of three decamireds or 30 mireds. Decamired filters can be used in combination to produce a variety of different DM values, as long as you combine filters of the same color. A No. 3 and a No. 12 decamired filter combined will cause a

FIGURE 5										
MIRED COLOR TEMPERATURE VALUES										
FROM 2,000 to 10,000°K*										
Kelvin Units	0	100	200	300	400	500	600	700	800	900
2000	500	476	455	435	417	400	385	370	357	345
3000	333	322	313	303	294	286	278	270	263	256
4000	250	244	238	233	227	222	217	213	208	204
5000	200	196	192	189	185	182	179	175	172	169
6000	167	164	161	159	156	154	152	149	147	145
7000	143	141	139	137	135	133	132	130	128	127
8000	125	124	122	120	119	118	116	115	114	112
9000	111	110	109	108	106	105	104	103	102	101
10,000	100	99	98	97	96	95	94	93	93	92

*Divide by 10 to obtain decamired value.

shift of 15 decamireds, or 150 mireds. The mired shift for reddish filters is a positive one, as they lower the color temperature and raise the mired value. Since the bluish filters raise the color temperature, they have a negative shift. To determine how great a shift you must make, subtract the mired value of the light source for which your film is balanced. If the color temperature of your light is greater than that of the film in use, you need a positive shift (reddish filter). A light source with too low a color temperature requires a negative shift (bluish filter).

To see how the system works, suppose that your film is balanced for daylight—this means a mired value of 182 (decamired 18). If you want to use the film with 3200°K illumination (deca-

mired 31), you'll need a filter or combination of filters to result in a decamired shift of 13, or 130 mireds. A No. 1 and a No. 12 decamired filter will cause a color shift of 130 mireds. Since you're using a film balanced for bluish daylight with a light source containing primarily yellow and red, you'll need bluish cooling filtration to match the tungsten light to the film; thus you'd use decamired filters B1 and B12.

Exposure increases required when using decamired filters are shown in Figure 6. If you're using decamired filters in combination, add the increase in f-stops required for each filter to find the total additional exposure necessary. If you calculate a particular combination of light and filter only to discover that the values required fall between two filter numbers, or between a given combination of filters, use the lower filter number or combination of filters.

Now that we know the fundamentals behind the mired system, let's see how to apply them. Suppose we're using daylight color film outdoors on a hazy day. The decamired value of our film is 18 and that of the light source 15. Subtracting 15 from 18 gives us a difference of 3, which tells us that a positive shift of 3 decamireds or 30 mireds is necessary. This means that we reach for an R3 filter. To convert the same film to studio lighting, which has a decamired value of 31, we subtract 31 from 18. This gives us a negative 13, which is expressed as -13DM and means we should use a B12 filter.

Most daylight color emulsions are balanced either at 17DM or 18DM. Tungsten emulsions are balanced at 31DM, except for Kodachrome 40 (Type A), which is balanced at 29DM. You should shoot a roll or two of daylight color film without using decamired filters to determine whether the results are too warm or too cool for your personal taste. If they're too warm or too cool, try a B1½ or R1½, respectively, to bring the rendition closer to what you're looking for.

COLOR BIAS AND FILTRATION

Color film is color film—right? Wrong—each brand of color film has its own distinctive color bias or rendition. Some are biased toward the cool or blue side, while others lean toward the warm or reddish side. Other variables also affect the color rendition of the emulsion: batch-to-batch differences in emulsions, film processing, and color shifts which occur as the film "ages."

Did you realize, for example, that your camera lens directly affects the bias of any color film you use? Today's lenses are color-corrected, to be sure, but certain optics tend to give a warmer, redder image than others, which might favor more of a bluer, colder image. This explains why a shot taken with your medium telephoto may differ slightly in color rendition from the same scene shot with your normal lens.

You can minimize the differences in color bias by sticking with one particular emulsion until you have learned its eccentricities. At the same time, use the same processing lab, don't keep color film on hand too long unless it's refrigerated, and keep notes on the effects of your different lenses. You may find a particular filter necessary with a given lens, but not required with other lenses. Whatever else you do, try to reduce the variables as much as possible and use filtration to compensate for the ones you can't eliminate.

FIGURE 6

EXPOSURE INCREASE FOR DM FILTERS

Red Series	Increase In f-Stops	Blue Series	Increase In f-Stops
R1½	¼	B1½	¼
R3	⅓	B3	½
R6	½	B6	1
R9 (R3 + R6)	¾	B9 (B3 + B6)	1½
R12	1	B12	2
R15 (R12 + R3)	1⅓	B15 (B12 + B3)	2½
R18 (R12 + R6)	1½	B18 (B12 + B6)	3

Filter manufacturers supply charts with their decamired filters to help you make basic decamired filter choices—these are summarized in Figure 7.

It's not advisable to mix daylight with photofloods or studio lighting when working with color film—not even the mired system can make adequate correction possible when mixed light sources are used with either daylight or tungsten-balanced film. The very best for which you could hope would be a compromise in which everything would be slightly askew. If light sources must be mixed, they should be of comparable quality—daylight and electronic flash, daylight and blue flash bulbs, etc.

The convenient thing about the mired system is its utter simplicity and consistency. Bear in mind that if you use decamired filters, you will not need the conversion or light-balancing filters, as the decamired variety will do the same job with even greater precision.

Color Compensating Filters

Color Compensating or CC filters are offered in various densities of six different colors: red, blue, green, magenta, cyan and yellow. Since these are the primary colors, a CC filter will control one color while leaving the others unaltered. The various densities permit close control of the amount of a given color to be absorbed. A CC20Y (CC for color compensating and Y for yellow) filter has a density of .20 to blue light (it absorbs about 37 percent of the blue light—see Figure 8) and allows red and green light to pass. A CC50R (red) filter has a density of .50 to blue and green light (it absorbs about 68 percent of

FIGURE 7

SELECTING DECAMIRED FILTERS*

Type of Film	Lighting Conditions	Filter Required	Exposure Increase in f-stops
Daylight	Bluish daylight, open shade, slight overcast or haze	R1½	¼
	Electronic flash or blue flash bulbs	R3	⅓
	Average sunlight combined with skylight	None	None
	Late afternoon or early morning sunlight	B1½	¼
	Clear flash bulbs	B6 + B1½	1¼
	3400°K photofloods	B3 + B6 + B1½	2
	3200°K studio lights	B12	2
	100-watt household bulbs	B12 + B3	2½
Type A	Bluish daylight, open shade, slight overcast or haze	R12 + R3	1⅓
	Electronic flash or blue flash bulbs	R12	1
	Average sunlight combined with skylight	R3 + R6 + R1½	1
	Late afternoon or early morning sunlight	R3 + R6	¾
	Clear flash bulbs	R3	⅓
	3400°K photofloods	None	None
	3200°K studio lights	B1½	¼
	100-watt household bulbs	B6	1
Type B	Bluish daylight, open shade, slight overcast or haze	R12 + R3 + R1½	1½
	Electronic flash or blue flash bulbs	R12 + R3	1⅓
	Average sunlight combined with skylight	R12	1
	Late afternoon or early morning sunlight	R6 + R3 + R1½	1
	Clear flash bulbs	R3 + R1½	½
	3400°K photofloods	R1½	¼
	3200°K studio lights	None	None
	100-watt household bulbs	B3	½

*These are starting points; more or less filtration might be required according to personal taste.

AVOIDING COLOR IMPACT

If you've ever come upon a breathtaking landscape that simply demanded you take a picture of it, only to be totally let down when you pull the print from the hypo, you've been a victim of color impact. Vivid colors have a tendency to mislead the amateur into thinking that certain subjects and scenes will have the same intensity in black-and-white. Most of us pass right by pastel shades because they contain far less emotional "pull." Strangely enough, these same light shades have a great deal of influence on the appearance of any subject, whether you shoot in color or monochrome. The intensity of color and its value when transformed into gray tones also depend a great deal on lighting. Sunshine brightens colors, making it harder to mentally transform them into relative gray tones in your mind. If you can learn to avoid being swept away by color impact, you can look at a scene objectively and make a rational decision regarding its value as a black-and-white subject. Once you've arrived at this point, selecting the proper filtration (if any) is far easier.

the two) while allowing virtually all of the red light to pass through.

CC filters are useful in making small changes necessary to compensate for deficiencies in the color quality of light sources, deficiencies in film emulsions due to manufacturing tolerances, and the effect of reciprocity failure in color films. Since CC filters come in all the primary colors, almost any color correction can be made with them, and they're useful when color rendition is critical. As color negative or print films have some color latitude, they can be corrected during printing with CC filters, but for critical work with color slide films, you'll have to shoot a test.

Although color emulsions are manufactured under strict quality controls, two rolls of the same brand of film may vary slightly in color balance if they are not of the same batch or emulsion number. One roll of a given chrome film may require a CC10Y filter to produce "normal" color, while another roll of the same film from a different emulsion batch may need no filtration. Variations within allowable manufacturing tolerances, although usually held to within a CC10 filter of a "standard," are one good reason for shooting a test when color rendition is critical.

Whenever you use extremely long exposure times (as when shooting in very dim light) or very short exposure times (as when using electronic flash at close distances), you are likely to encounter reciprocity failure in the film. This is a shift in color balance and a corresponding loss of speed caused by longer or shorter exposures than those for which the film was designed. For the majority of color films, the "safe" range of exposure times is between 1/10

and 1/1000 second. At longer or shorter exposures, you may have to use a CC filter to compensate for the color shift caused by reciprocity failure. Some manufacturers provide exposure and filter compensation data for very long or very brief exposures with their film instruction sheets; others don't, so you'll just have to shoot a test, look at it, and then decide what correction, if any, is necessary.

While they are normally used to make color corrections, CC filters can also be used to make color creations. They can intensify colors, create moods and do all kinds of wild, interesting things for your pictures. To find out exactly what you can do with them, experiment. This

FIGURE 8

CC FILTER DENSITY/TRANSMITTANCE

Density	Transmission (%)	Absorption (%)
.05	90	10
.10	80	20
.20	63	37
.30	50	50
.40	40	60
.50	30	70
.60	25	75
.70	20	80
.80	16	84
.90	12.5	87.5
1.00	10	90
2.00	1	99

FIGURE 9

COLOR COMPENSATING FILTERS

Red (Absorbs blue and green)		Magenta (Absorbs green)	
CC025R	0	CC025M	0
CC05R	⅓	CC05M	⅓
CC10R	⅓	CC10M	⅓
CC20R	⅓	CC20M	⅓
CC30R	⅔	CC30M	⅔
CC40R	⅔	CC40M	⅔
CC50R	1	CC50M	⅔

Cyan (Absorbs red)		Blue (Absorbs red and green)	
CC025C	0	CC025B	0
CC05C	⅓	CC05B	⅓
CC10C	⅓	CC10B	⅓
CC20C	⅓	CC20B	⅔
CC30C	⅔	CC30B	⅔
CC40C	⅔	CC40B	1
CC50C	1	CC50B	1⅓

Green (Absorbs red and blue)		Yellow (Absorbs blue)	
CC025G	0	CC025Y	0
CC05G	⅓	CC10Y	0
CC10G	⅓	CC10Y	⅓
CC20G	⅓	CC20Y	⅓
CC30G	⅔	CC30Y	⅓
CC40G	⅔	CC40Y	⅓
CC50G	1	CC50Y	⅔

Numbers following filter designations are amount lens opening should be increased (approximately) when using filter, in f-stops or fractions thereof. Note that subtractive primary colors (cyan, magenta and yellow), which transmit two-thirds of the spectrum, require less exposure compensation than primary colors (red, green and blue), which transmit only one-third of the spectrum.

will not only provide you with some unusual effects, but will also give you a better understanding of filter usage.

Generally speaking, you'll find the CC30R to be the most commonly used. Its applications vary widely, from correction in underwater photography to eliminating color distortion in pictures taken through transparent plastic windows, such as those used in airplanes or on some railroad cars. Some exposure increase is required when using CC filters. Refer to Figure 9 to determine the additional exposure that is necessary with each filter type/combination and don't forget to add the increases if filters are used in combination.

Fluorescent Light Filters

Fluorescent lighting has a discontinuous spectrum; that is, it does not produce a uniform or standard distribution of red, blue and green wavelengths. For this reason, it presents rather difficult problems, resulting in undesirable color casts when it is used as the major illumination source for photography. While a tungsten lamp puts out a little blue, more green, even more yellow and much red (as we move from the shorter to longer light wavelengths), in a smoothly increasing pattern, a fluorescent light may put out hardly any blue, some green, much orange and no red—or any other combination you might care to name.

Fluorescent lights also vary in color quality from lamp to lamp, from brand to brand, with age and other factors—there seems to be no two alike, although our eye can't tell the difference. Unfortunately, the filtration required for proper color rendition on film varies just as widely—from film to film, lamp to lamp, brand to brand, etc. There are so many variables that we just don't have room here to list the correct filtration for every possible combination.

Until a few years ago, color correction when working with fluorescent lighting was possible only with CC filters. This method is still recommended if precise results are desired, but experimentation is still necessary to find the best choice of filters. Figure 10 will provide starting points, but it's suggested that you use negative color film, since it permits final color correction to be made during printing.

As an alternative to the use of CC filters with fluorescent lighting, there are two special filters that can be used to remove most of the bluish-green cast from flesh tones photographed under fluorescent lighting. The FLD is used with daylight color films and can cope adequately with a mixture of daylight and fluorescent lighting. The FLB is for use with tungsten emulsions and will handle a mixture of tungsten and fluorescent lighting with acceptable results. Both filters generally require an increase in exposure equal to one f-stop, and since fluorescent lighting varies during AC cycles, it's highly desirable to limit the shutter speed used to 1/60 second or below if you want to obtain uniformity in the quality of color and illumination. Again, negative color film is best because of the correction possible during printing.

FIGURE 10

CC FILTER RECOMMENDATIONS FOR FLUORESCENT LIGHTING

Type of Tube	Film Type Daylight	Exposure Increase in f-Stops	Film Type Type A or B[1]	Exposure Increase in f-Stops
Daylight	30R + 10M	1	85 + 20M + 10R	1
Cool White	30M[2] or 20M + 30C	⅔ 1	50R[2] or 10R + 10Y	1⅓ ⅓
White	20C + 30M	1	30R + 10M	1
Warm White	40C + 40M[2] or 60C + 30M	1⅓ 1⅔	10R + 20M[2] or None	1 0

[1] Add a CC10Y for Type B films.
[2] Variations in tubes may require any combinations between the two recommendations given.

Prism Attachments

Prism attachments or multiple-image lenses are known by a wide variety of names—multivision, miracle image, mirage, trick prism, multiple mirage, etc. Regardless of the brand or trade name under which they are sold, these are made from transparent optical glass and transmit virtually 100 percent of the light passing through them; thus no exposure compensation is required. Since these attachments are manufactured with a trapezoid surface on one side, they split or divide a single subject into three or more identical images. Depending upon the particular design being used, you can superimpose repeating images in a linear, radial or concentric pattern. The various patterns presently offered are shown in Figure 1, each of which produces a different effect.

The prism attachments are manufactured in a double ring mount (similar to that used by a polarizing filter) which screws into your camera

Prism or mirage attachments provide unusual effects, but should be used tastefully. This 5R rendition of Julie Swanson was shot at f/16 for increased sharpness of the images.

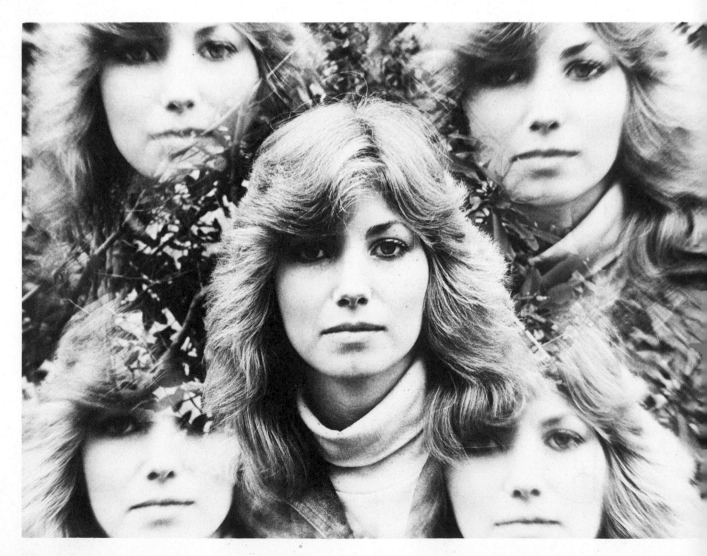

lens. Depending upon the prism surface, some are threaded to accept another filter or lens hood. Most have a small handle or lever on the front ring which allows you to change the position and/or pattern of the images created without accidentally unscrewing the attachment from the lens.

1

2

Simple subjects like this portion of a Rose Bowl parade float (photo No. 1) turn into a complex myriad of color (photo No. 2) with the help of a 3T prism.

The most recent innovation in prism design, the compound multiple-image prism (Figure 2), consists of a pair of identical double-faceted prisms in a rotating mount. This lets you orient the two prisms in any position desired. When the prism axes are parallel, two identical side-by-side images of an object will be recorded. Aligning the prism axes at right angles to each other will produce four identical images. A variety of other patterns can be produced by in-between settings of the variable prisms.

Regardless of the pattern, the center segment of the prism will produce the sharpest image. Diffraction softens the other segments' images to some degree. Image sharpness is also dependent upon the choice of lens opening. At large apertures (f/4 or larger is preferable), the center image will be slightly diffused, with a considerable loss of image contrast and color saturation affecting the other images. As you stop the lens down, the outer images will gradually become more distinct, brighter and almost as sharp as the center one.

Best results are obtained at larger apertures, but this can prove to be a problem with a medium- or a high-speed film in bright sunlight. One answer is to use a contrast or neutral density filter between the lens and the prism attachment.

FIGURE 2

VARIABLE PRISMS

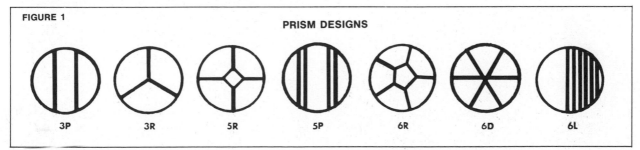

FIGURE 1

PRISM DESIGNS

3P 3R 5R 5P 6R 6D 6L

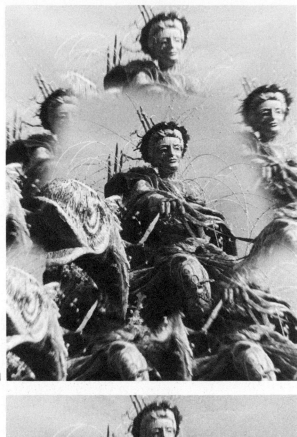

This will reduce the light reaching the film sufficiently to let you open the lens up. Use your depth-of-field preview and check the effect at each usable aperture to get precisely what you want for subject treatment.

Look for simple subjects with an uncluttered background. Try to choose a dark background for light-colored subjects and vice versa. The bold contrast between subject and background helps the visual impact, as well as providing a higher contrast level in the images surrounding the center. If the subject appeals to you in spite of a cluttered background, either use the six-segment linear pattern or mount the camera on a tripod and rotate the prism slowly but evenly during a slow exposure. This will produce a circular blur in the surrounding images while the

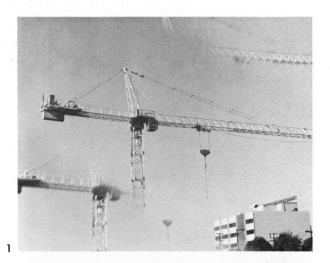

The aperture used has a definite effect on the images, as shown in this pair taken at f/2.8 (photo No. 1) and f/16 (photo No. 2).

Adding a red filter to the 3P prism and stopping the lens down (photo No. 2) darkens the sky and sets off the sharper image.

one in the center remains sharp and stationary. After working with these attachments for awhile, you should become accustomed to previsualizing the potential subject and be able to select the most effective prism pattern and f-stop by second nature.

Prism attachments differ in their effect according to the focal length of the lens. They are most effective when used with the camera's normal lens. A moderate wide-angle lens tends to clump the images in the center of the picture area and cause corner vignetting. A moderate telephoto will cause a divergence of the·images to the side of the picture frame, cutting off parts of each surrounding image. But so what—each of these effects may be exactly what you're looking for, so don't be afraid to experiment.

If you use a camera which produces 6x6cm negatives, you'll have to use extra care in composing your picture when using a prism attachment. Since the negative is square, it's easy to fall into the trap of neatly arranging the multiple images within the square frame only to find that when you come to make an 8x10 print from the square negative, some of the prism effect will have to be cropped out. If you can enlarge fullframe to produce a square print, this should prove to be no problem, but a full-frame print is not always desirable. At any rate, it's a good idea to keep this potential problem in mind and either decide in advance how you plan to print the shot, or compose and shoot separate pictures for both possibilities.

Multicolored prism attachments are also of-

The 3T prism arranges a subject in a triangular manner (photo No. 1); the 3P layers it (photo No. 2).

A 3T used with a moderate telephoto fills the frame (photo No. 1), but the focal length is too long to accommodate a 6R (photo No. 2) and much of the effect is lost.

fered by some manufacturers. Once available only in the six-segment radial pattern, these are now offered in three- and five-segment radial patterns and in three different types. The first type (6R) is a continuous and blending color spectrum which is incorporated within the glass, much like a color wheel. The second (3R) is a multifaceted prism with a different color or hue applied to each facet. The third is a two-color, five-segment radial pattern with the color applied as in a split-field filter—one half is one color and the other half a second and contrasting color. All three types produce spectacular re-

sults when used with the proper subjects, but you may find their use quite limited relative to their cost.

Since multicolored prisms are very expensive, you might want to create your own with a few filter gels and a regular prism attachment for which you no longer find much use. Each gel must be cut as carefully as possible to fit a given facet, but if you work slowly and precisely, this is not too difficult. Thin down some rubber ce-

Las Vegas lights are an ideal subject for prisms, turning a simple sign into a symphony of light and color.

ment and use a toothpick to apply a tiny amount to the corner of each facet; then place the gel segments in position.

When done correctly, the small amounts of rubber cement used will hold the gel sections in place without interfering with the visual effect. This homemade version can be made with any prism pattern, and when you tire of the effect, the gels can be removed and the prism restored to normal duty without difficulty. Be sure to arrange your colors so that they'll contrast with each other. You don't want two shades of a particular color side-by-side—break them up with a strong contrasting color in-between.

Prism attachments can also be used with other special effect filters, such as laser or diffraction filters, cross screen and star filters, etc. The possibilities are up to your imagination and good taste. Pick the right combination and the proper subject and you'll end up with a knockout picture—miss the boat with either and the result will be a resounding dud. Prism attachments produce far more spectacular effects in color, so be especially aware when working with black-and-white film.

These devices have become quite expensive in the past few years, and two or three different ones represent a considerable investment today—especially if you're interested in one or more of the multicolor prisms. Those who own more than one camera, or plan on acquiring another camera which will take a different size attachment, might think that they could save a bundle of money by buying one size prism at-

Capturing the lights at different intervals produces entirely different pictures.

5R Prism

5R and 3P Prisms

73

tachment and stepping it for use with the other camera. Unless you're considering a 3mm step as the maximum, such as 52mm to 49mm or vice versa, you could be in for a surprise. Stepping a smaller prism to your lens can result in vignetting and a tendency to draw the images together. Using a larger prism than necessary may well cause a cutoff of some of the surrounding images. How great these effects are will depend upon the focal length of the lenses in question and the degree of stepping necessary to make the adaptation.

There are other possible applications for the use of prism attachments, but you'll have to experiment a bit to hit upon the proper subjects. Try combining two prism attachments to produce an even more unusual effect. I've found that using one parallel and one radial prism leads to some interesting patterns, but you might find a 3P and 5P or 3R and 5R combination intriguing. Be sure to reverse their position on the lens and check out the difference in the patterns produced.

Another use for the prism attachment comes in the darkroom. With the proper adapter ring, you can fit one to your enlarging lens and transform a straight negative into a multiple-subject print that would otherwise take hours to get right by conventional means, even if you could figure out how to print it. Again, for best results, the prism attachment should closely approximate the enlarging lens in diameter to prevent excessive image crowding or spreading. And don't forget to try revolving a 5R or 6R prism during exposure to produce a sharp center image surrounded by a blur.

Prism attachments can be among the most creative and at the same time frustrating accessories available to the photographer. Used with insight and skill, they're creative tools, but trying to add something to a basically uninteresting subject can be a most frustrating experience. Simply multiplying and superimposing an average subject with a prism attachment usually produces little more than a visual mess. To use these accessories successfully, you should look for a simple but bold subject which *creates* a strong pattern by itself—not one that *contains* a strong pattern.

Isolate a flower against the sky or a person against a fence. Make sure that there's sufficient empty room around your subject to place the multiple images. Look for a contrasting background. You'll find that a dark background will work more effectively than a light-colored one, as the latter has a tendency to lighten the secondary images. Neon lights photographed at night are an ideal subject for prism attachments, or what to do in Las Vegas after your money runs out.

Try infrared film and a red filter to produce a black sky for black-and-white prism shots, or combine a red and polarizing filter for a similar effect. With color film, keep the colors in your subject to a minimum, or the effect may turn out to be little more than a mishmash or color salad.

Larry Hamill used five-image Cokin multiple-image filter to photograph bust head on which color slide was projected to produce this effect shot. (Photo copyright© 1980 by Larry Hamill)

Left:
This sequence shows the many and varied effects possible by rotating the prism during the exposure. The effect varies according to amount and speed of rotation, and whether it is one-way or back-and-forth movement.

Cross Screen and Star Filters

Those who watch much television have undoubtedly seen this effect. Cross screens and star filters are used on some network variety shows, but are particularly favored by local stations who want to add a touch of "class" to their non-network programming. Manufactured of optically clear glass or plastic (thus no filter factor is involved), cross screen filters contain a series of minute cross line grooves engraved on the surface at right angles to each other. When these lines intersect a point light source, they split its rays into one or more cross flares to create a brilliant specular highlight. Used with color film, the effect is even more spectacular, as the cross flare is also refracted. This causes a spectrum effect to emanate from the light. Cross screens are designated as four-point star filters by some manufacturers.

Several variables are involved with selecting the proper cross screen to give the desired flare

Star effects differ according to the point light source. An 8-point star created a prism-like effect on this Las Vegas sign.

effect. The first is the size and crosshatch of the grid pattern as shown in Figure 1, which is available in 1mm, 2mm, 3mm and 4mm sizes. The finer the grid or mesh pattern used, the smaller but more pronounced the effect will be. The coarser grid patterns produce fewer cross flares, resulting in a more subtle and less intense effect.

The intensity of the point light source, as well

Strong individual point light sources will deliver intense star flares.

A multitude of weak point light sources results in a slightly diffused rendition, with few strong stars.

as its size, is another variable. The smaller and stronger the light, the greater the effect will be—regardless of the pattern size used. Distance is a third variable to be considered in selecting the appropriate filter. The closer the light source to the camera, the more pronounced and intense the flare lines will be.

To put this into practical examples, let's consider a city skyline taken at night from an elevated vantage point vs. a single street lamp 35-40 feet from your camera. The skyline will contain hundreds of tiny point light sources. A 1mm grid pattern will work best in this case, since you need the fine pattern to intersect as many lights as possible. Even so, the effect will be a subtle one, as the distance of the lights from the camera will result in relatively small flares. The result, however, will not be as subtle as that created by a 4mm pattern, which will not affect as many of the lights in the picture. Since the single street lamp is closer to the camera, its image will be much larger in your picture area. This means that it will react more intensely to the coarser 4mm pattern.

The lens aperture is an equally important variable since it affects the size and intensity of the flare. A cross screen effect seems to work best when used at apertures between f/4 and f/8; smaller apertures will produce finer, sharper flare rays, but they also have a tendency to minimize or even lose the effect in some cases. Larger lens openings will often produce out-of-focus cross flares, an effect that can be visually distracting instead of enhancing your subject.

The aperture at which a given cross screen grid or pattern works most effectively is subject to experimentation. As we've seen, the flare effect depends upon the size and pattern of the grid, as well as the light intensity, camera-to-light distance, and to some extent, the focal length of the lens with which the filter is used. As a 100mm lens used on a 35mm camera doubles the image size over that produced by a 50mm lens, the same cross screen will have a different effect when used with the two different focal lengths.

Star filters are a more complex variation of the cross screen. By engraving triangular-shaped cross lines which interlock, a six- or eight-point cross flare is created, rather than the four-point flare of the ordinary cross screen.

You can also produce a similar effect by using two four-point cross screens to create an eight-point flare. Filter manufacturers offer a variable cross screen or star filter. This simply contains two ordinary cross screens. Some are set in independent rotating rings while others use one fixed cross screen and one that rotates. Rotating one or both rings permits grid adjustment at varying angles. Variable cross screens tend to produce a long, wide and multicolored four-point cross flare.

The six- and eight-point star filters are more useful with larger point light sources, or those which are relatively close to the camera. When the light source is not really intense or is too far away, the finer pattern of the filter turns the light into a circular hub with only tiny, thin flares protruding from the center blur. The finer cross

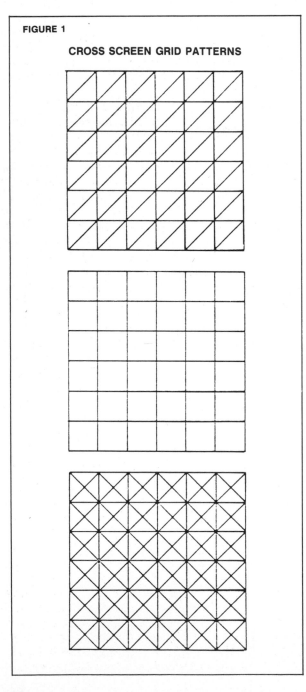

FIGURE 1

CROSS SCREEN GRID PATTERNS

screen grid patterns and star filters produce a slight amount of diffusion which will work to soften the entire image. This is another reason for sticking with the larger patterns when there are only a few light sources included in your picture.

It's entirely possible that you'll find occasions when the number of highlights or light sources in the picture will cause visual confusion when a cross screen or star filter is used. In such cases, you should switch to a coarser grid pattern to limit the number of cross flares in the picture. Many photographers find these filters most effective when only a few flares are created, as in catching a reflection in the eyes of a model to create a star effect in her eye—a continuing cliche of glamour photography.

The star effect can add interest to otherwise ordinary photographic subjects.

Left:
When photographing reflections with a star filter, watch the effect carefully. If the light source illuminating the reflective surface is at an angle, a broken star will result, as shown in this section of a fashion model wearing diamond earrings.

Regardless of how you intend to use a cross screen or star filter, experimentation is the best advice. No single one of these filters will give you all the variations in effect in which you might be interested. Because of the variables described above, selecting a particular star filter or cross screen by trying it on your lens in the camera store to check on the effect is more academic than practical.

If you're enamored of the flare effect, you really need to have an assortment of grid patterns at hand. This means that you should probably buy several different grid patterns from different manufacturers to cover the various occasions for which you might want to use the technique. This will allow you to pick the proper one according to the subject, light intensity, camera-light distance and aperture to be used. If you're on a budget, or just want to be covered for this particular effect, I'd recommend the 2mm cross screen as the single most useful size/pattern.

Incidentally, choosing the cross screen or star filter you need is complicated somewhat by a lack of standardization in descriptive terminology. To glamorize the effect and differentiate their line from that of the competition, manufacturers and distributors think up all kinds of suggestive names for their filters—Crystal Cross, Sunny Cross, Snow Cross, Starburst, Variocross, Vara-Cross Star Effect, etc. If you order by mail, be sure that you know the grid pattern size and design of the filter you want or you may be disappointed in what you get.

Those who can't find exactly what they want in this type of filter, are on a really tight budget, or just want to be creative can make their own cross screen. Window screening material sold in hardware stores is a good starting point, since it usually comes in several different mesh sizes. A small section of each mesh size can be held in front of your SLR's lens and its effect checked out with a given light source. Repeating this procedure with each different mesh size will give you some idea of the variations in the effect which are possible, but like trying filters in the camera store, the effect is valid only with that light source.

Such screening can be cut to a circular shape to fit an adapter ring, or if you have a filter gel holder, you might find it more appropriate to cut the material into three-inch squares. Since screen mesh is usually a dull silver or aluminum color, spray paint one piece black and a second piece bright aluminum for a variation on the effect. The black screening will subdue the flare effect somewhat, resulting in thinner, more dis-

Kalt Halo Star-8

Camrex 8-point Star

Kalt Crystal Cross Star 6

Kalt Soft Cross 4-point

Camrex Star 4 Cross Screen

Prinz Vario-Cross

tinct flares. The bright aluminum screening will increase the flare effect, leading to larger, more diffused flare images. Different colors can also be used if the mesh is to be combined with color film. In this case, the flares created by the screening will take on a slight color cast.

O.K, now that we know all about cross screens and star filters, how can we use them most advantageously? While these filters can be used with any camera, an SLR is the best choice since it permits you to see the exact effect and adjust it to suit your preference, if necessary. If you're working with a non-SLR camera, you'll have to take whatever you get.

After attaching the filter to your lens, use the camera's depth-of-field preview to determine the exact effect at each aperture and select the lens opening that gives the most suitable flare. There's no need to accept the positioning of the flare points as final. Remember that rotating the filter will change their orientation. With a non-variable filter, this means screwing it onto the lens and then backing it off the fraction of a turn necessary to align the flare points in the desired direction. When using a variable filter, try separating the flare points or bringing them closer together as appropriate for the subject.

Since the flare effect shows up best against a dark background, these filters will produce their most striking effects with night pictures, but don't hesitate to try one during daylight hours, especially where there are shimmering highlights on water. When a light-colored background cannot be avoided, the effect can be intensified by deliberately underexposing between one-half and one full stop.

Lengthy exposures will cause the flare lines to bleed somewhat, while rotating the filter during an exposure of several seconds' duration will produce a propeller-like effect in which the flare lines revolve around the highlight or light source. Since a smooth rotation will produce an effect different from one that is hesitant or jerky, it's a good idea to use a tripod and make several exposures of your subject. If you have a variable filter, try holding one cross screen stationary and rotate the other for still another type of effect.

Don't forget that the closer you are to a bright highlight or point light source, the larger and more intense the effect. If one effect doesn't particularly captivate your fancy, move your

camera position, change your angle slightly, or switch the focal length of your lens. Any of these alternatives will reorient the pattern effect and produce different results.

What subjects work well with these filters? Obviously, virtually any night scene will provide the greatest amount of flare, but exercise good judgment if the scene is filled with lights or it may become too visually confusing. Too little is usually better than too much. Sunset and sunrise shots in which the sun is partially visible also work well, as do beach or water scenes in which there are numerous specular highlights on the surface of the water. If you're shooting air races or other subjects in the sky, try a red filter to darken it and then add a cross screen or star filter and try to include the sun (or a part of it) in one corner of your picture. The same trick works well for boat races when the sun is bright and the water choppy.

You can give a visual boost to pictures which contain jewelry, tableware, crystal or cut glass, candle lights, Christmas trees decorated with strings of lights, etc. The flare effect can also enhance portraits when your subject is wearing jewelry, provided you use good taste in producing appropriate patterns. In this case, for example, you certainly don't want to fill the picture with flare lines, nor should you revolve the filter to create outlandish effects which will detract from your subject.

These filters are especially useful when photographing concerts or night club acts, particularly if the performers are wearing sequined clothing. Again, you don't want to overdo the effect, so watch the grid size and pattern and you should end up with some spectacular visualizations of the entertainment. If you're using flash, you'll probably be limited in the lens opening you can use, so take this into account when selecting the proper filter.

As a final suggestion, try combining the use of a cross screen or star filter with other special effect filters, such as prism attachments. Again, good taste is necessary, since you're multiplying and superimposing both the image and the resulting flare lines. Keep compositions simple and to the point, such as using a 3R rendition of an old-fashioned street lamp with a 4mm grid pattern superimposed to produce one flare effect. Since there's nothing to prevent you from pulling out the filter and visually checking its effect on any subject, don't be afraid to experiment with whatever comes before your camera lens—the results may please you more often than you'd think.

Left:
All star filters are not alike in their effect, as shown in this series.

Fog Filters

1

Most of us appreciate the pictures that result from rainy, snowy and foggy days, but as photographers, we're not too keen about working in adverse weather. The filter manufacturers haven't been able to make our lives easier by developing a filter that simulates rain or snow—not yet—but they have developed "fog" filters which can be used to suggest the illusion of fog and/or mist.

Fog filters are simply a piece of plain, very finely ground glass. Most filter manufacturers offer them in two different strengths, but BdB and Tiffen let you lay it on thick with four and five different densities, respectively, each of which can be used alone or in combination to create a large variety of different "fog" effects. Since they are made of plain glass, fog filters require no exposure compensation, although Tiffen does recommend about a ½-stop increase with the first four filters in the range and a full stop with the No. 5 filter for a misty fog atmo-

Fog filters create an illusion of mist without materially affecting subject definition (photo No. 1). Using the same filter under the enlarger lens creates a totally different effect. Note that like a diffusion filter, it causes shadows to bleed into highlights, as well as diffusing the subject considerably (photo No. 2).

2

sphere without a loss in contrast.

Shooting in real fog is one thing—using fog filters is something quite different. Here's how the two stack up. Real fog acts as a diffuser—it scatters light and reduces image contrast. Colors tend to become muted and fade into each other, producing delicate soft tones which create a definite mood in the picture. The thicker the fog, the greater the diffusion and the more pronounced the effect.

Working in real fog can be a downer for many—it's cold and damp, and you're never quite sure about the right exposure to use, a tricky subject at best. Since you want to maintain the low contrast level, a slight amount of underexposure is preferable when using negative films, whether black-and-white or color. You should close the lens down about ½-1 stop beyond that suggested by your light meter. Of course this leads to a thin negative, which requires much patience and control to print properly and still maintain the desired mood. On the other hand, a color slide requires ½-1 stop overexposure—or just the reverse. Why? Because it is a reversal film and overexposure reduces the color saturation, giving the slide a thin, washed-out appearance.

Simulating a fog effect with these filters simply creates the illusion of fog or mist. It does not affect the definition and/or sharpness of your subject. If it did, the entire effect would appear false. As a result, the image seems to be naturally veiled by a misty fog. Since the effect will vary according to the lens opening used, try to work at f/5.6 or larger apertures. As you stop down beyond this point, the degree of fog effect produced diminishes, and at an aperture of f/16 or f/22, you might be hard-pressed to detect it in an enlargement.

Obviously, fog filters have a good deal of potential for the creative among us, but they also have two major limitations of which you must be aware. The first drawback is simply that virtually all of them give a uniform veiled effect to everything in the scene. Regardless of whether your subject is in the foreground or background, the fog effect will be of equal density in all parts of your image. Real fog, of course, has a greater effect as depth increases—the farther that objects are from the camera, the less visible they are. This means that you have to choose your

No filter

subjects with care so that they show little or no signs of depth.

The Cokin system filters, however, are graduated, and by careful composition and choice of subject, can produce a dense fog effect in the background while the foreground contains only a slight effect. This is far more realistic with a wider variety of subjects, and is only one of many reasons for considering the system filter approach.

When using nongraduated fog filters, try to keep your subject matter on a plane as parallel with the camera as possible to minimize the depth problem. This could be a distant view with no foreground, a composition with only a foreground, or even a portrait taken against an overcast sky.

Depending upon your subject matter, you might also consider switching to a wide-angle lens—24mm or shorter focal lengths will flatten out the perception of depth in the picture by reducing the image size. You can then eliminate undesired expanses of foreground or background in the darkroom by cropping them out during enlargement. As an alternative to this ap-

David Neibel shot this series to demonstrate the fog filter effect on a landscape. Note that the subject is essentially plane parallel with the camera and all in a mid-range from the lens.

proach, try a moderate telephoto—anything from 135mm to 180-200mm. Its subject compression effect not only lowers contrast (which means you might want to increase exposure by ½ stop), but its more narrow angle of view will limit what you can include in the picture.

This brings us to the second drawback. If the fog effect is to be as realistic as possible in your pictures, the filter should be used for landscape or scenic work only on overcast days. Strong directional lighting of any type is rarely found in the real thing, especially when the pea soup is thick.

The one major exception to this rule would be the use of a graduated fog filter with a sunrise or sunset scene which includes both water and the sun. For example, a rising sun over a lake bordered by dense foliage, or a shot across a marsh at sunrise, could benefit from the use of

Hoya Fog A

Hoya Fog B

Hoya Fog A & B

such a filter and still produce a natural picture.

When you're working in black-and-white and want a highly realistic fog effect in a scenic or landscape, load up your camera with one of the coarser-grained ASA 400 emulsions. The contrast of such films is lower, and since their larger grain structure will be more evident in the print, it will tend to further heighten the illusion of fog generated by the filter.

It's easy for me to specify exposure recommendations based upon my particular technique, but they may not work for you. Contrast, as we know, is dependent upon the film selected, the exposure it's given, and the developer/agitation method used. In your initial experiments, I'd suggest that you bracket a series of three exposures—one as recommended by the meter, a second ½ stop less, and the third a full stop under. By approaching the problem of exposure with a fog filter in this manner, you should be able to settle upon a rule of thumb that applies to your particular technique.

Fog filters work well with black-and-white film, but since they also tend to desaturate and mute strong colors, they can be especially effective when used in color shots. Handled properly, you can use them to create a misty, dreamlike effect that will accentuate a romantic mood. You might also try combining a light-colored contrast filter with the use of a fog filter. This is particularly easy with system filters like the Cokin, since the system contains two densities of graduated color filters. In addition to a bit of work to find the right subject, it takes a little taste to determine the proper color to be used with a fog filter and come up with a picture that's effective, but when you hit the mark, the results are worth the effort.

Where can you find appropriate subjects? They're all around you. While it's true that most of us associate fog and mist with the countryside or seashore, that particular stereotype shouldn't stop urban dwellers from indulging in this type of photographic fantasy. After all, cities generally have parks, which can be ideal locations—especially those with a body of water incorporated within their boundaries.

And don't overlook the possibilities offered by the city environment. At one time or another during the year, you'll find real fog in most cities, so its presence among the skyscrapers of New York or any other major city would not appear out of place in your pictures. City fog can create some very unusual effects, so pay attention to it and use what you see as a guide when creating your own fog pictures.

Diffusion and Vignetting Filters

When you stop to think about it, photographers are a strange breed. Lens designers work overtime to come up with optical formulas that reproduce an image as "sharp as a tack." We pore over camera ads and haunt photo stores in a constant attempt to upgrade our camera's lenses. We buy the inexpensive ones we can afford and count the days until we can swap them in for "sharper" lenses. Considering these well-documented quirks which are characteristic of the amateur photographer, it's interesting that many of us go out of our way to deliberately take pictures that are unsharp.

There are literally dozens of ways to diffuse an image in the camera, but the results differ according to the method used. The trick is to soften the image without reducing the overall contrast. Toward that end, photographers have been smearing petroleum jelly on plates of clear glass and taking pictures through the blurry mess since the first jar of the stuff appeared on drugstore shelves. Today, we apply it to haze or skylight filters, but the results remain the same. The possibilities are numerous and varied, but the effects can seldom be duplicated in subsequent shooting sessions. Although an immensely creative tool in the hands of the skilled photographer, diffusion by petroleum jelly is a messy means to an end for most of us.

Nylon mesh was meant to beautify the legs of American women, but we stretch it in front of our lenses to impart a luminous quality to our subjects. Several professionals made their reputations in the '30s and '40s with this "stocking technique." Nylon produces results that are quite different from those obtained with petroleum jelly, but it does offer consistency, and the effect can be duplicated when desired.

Diffusion offers the amateur photographer a continuing challenge to be creative. From cheesecloth to crinkled cellophane, every serious amateur has his own technique for producing diffused or soft-focus pictures, but that hasn't stopped ingenious manufacturers from devising a variety of lens devices and attachments to do the job. The wide variety of commercial filters which will create this effect can be supplemented by an ever greater number of homemade diffusers, as well as special diffusion-producing lenses offered by Fuji, Mamiya, Minolta and Spiratone.

Space is far too limited here to delve into them all, and with one exception, the various devices and attachments seem to disappear from the market after a brief period. The exception is the PicTrol, a device designed for producing diffusion while enlarging, but adaptable for use on the camera lens. It's highly regarded among knowledgeable photographers because it doesn't reduce contrast as do most other soft-focus methods. We'll come back to the PicTrol shortly, but let's take a closer look at diffusion filters.

Commercial Diffusion Filters

The easiest way to soften your picture image and obtain that dreamy quality called diffusion is to use a diffusion filter. These are manufactured in three different designs and several different strengths. The most common diffusion filter is simply optical glass which has been ground to produce the proper amount of image spread. The second design uses a stippled pattern on one side of the filter, while the third contains a series of fine concentric lines. These lines are spaced more closely at the edges to maintain an even amount of diffusion at all apertures. This produces an effect similar to that caused by spherical aberration, the traditional diffusion tool of the old-time portrait photographer. Regardless of the pattern used, all diffusion filters create their magic by spreading the highlights into shadow areas, and are most effective when used under sunny or bright conditions outdoors, or with studio lighting indoors.

You should realize that a diffused image, as produced by these filters, is quite different from one that is out-of-focus, or blurred by camera movement. It's really a combination of a sharp and a slightly unsharp image which tends to hide minor skin blemishes and wrinkles. When shooting portraits with a 35mm camera, diffusion is the only practical approach since retouching the small negative is both difficult and impractical. The technique is rarely used with male subjects, but is reserved instead as a

Right:
The degree of diffusion depends upon the filter, subject distance and lens opening. Bill Hurter combined two Zeiss Softar filters (I and II) and opened up to f/2.8 for this head shot of actress Kelly Holland.

No Filter

Hoya Diffuser

Vivitar Soft III

Camrex Diffuser

Hoya, Vivitar and Camrex Combined

To show the effect of different commercial diffusion filters, Bill Hurter photographed this head-and-shoulders series of Kelly Holland at f/4.

means of producing a romantic and more flattering interpretation of the fair sex.

Portraits are not the only subject matter which can benefit from diffusion. Virtually any subject that comes to mind can be treated to a soft-focus effect—the key is in keeping the lighting uniform and selecting the right degree of diffusion. Some subjects work best with only a slight overall softening of the image; others demand the misty appearance of complete diffusion, with colors blending and highlights flaring.

Backlighted subjects produce interesting effects when diffusion is introduced. The combination adds a touch of glamour when detail isn't that important. Bracket your exposures instead of relying upon a meter reading with backlighting. Since diffusion works especially well with color film, look for bold graphic subjects containing large masses of color/design. Try diffusion with a beach scene and setting sun, a forest with light streaming through the tree branches, a field of flowers, or even an individual flower. Add still lifes to your list of possibilities, which is limited only by your curiosity and imagination.

The amount of diffusion produced depends not only on the filter strength that is used, but also on the size of the lens aperture. Large apertures give maximum diffusion, with a noticeable subduing of the effect as the lens is stopped down. When a correct exposure requires the use of a small aperture, an appropriate neutral density filter can be combined with the diffusion filter. If depth-of-field considerations make the use of smaller apertures necessary, increase the strength of the diffusion filter used, or combine two of the same to amplify their effect.

To assure the best results, focus your camera lens sharply on the subject *before* installing the diffusion filter. Trying to focus with it in place can pull your eyes out of their sockets. Use your camera's depth-of-field preview to select the exact aperture to be used according to the degree of diffusion desired *with* the filter in place. Diffusion filters can also be used to soften a sharp image in the darkroom by attaching one to the enlarger lens. And don't overlook the possibilities of using light-colored contrast or other filters in combination with diffusion.

The original PicTrol was produced by Arkay Corporation for use with an enlarger. Diffusion created in the darkroom is opposite in effect to that produced in the camera. Instead of highlights that spread into shadow areas, shadows spread into highlights—remember, we're dealing with a negative image in the darkroom. Pho-

tographers fascinated with the flexibility offered by this diffusion device quickly converted it for use directly on the camera, and now we have a commercial version known as the Converted PicTrol.

Like its predecessor, the Converted PicTrol has a movable ring around its circumference. This ring contains numbers from 1 through 10 and letters from A to D. Rotating the ring changes the positioning of the six transparent plastic blades inside the barrel of the PicTrol. If you work with one of these, you should do a considerable amount of experimentation, since a full range of diffusion effects is possible. I've found that once the PicTrol has been adjusted so that the image in the viewfinder looks just right, it's best to back off one or two settings on the amount of diffusion. If you don't, an effect which looks right through the viewfinder becomes too intense when the image is enlarged.

Stopping the lens down too far may cause a white halo to form around the center spot. This can be avoided by using a neutral density filter. (Photo by David Neibel)

You may not agree with my findings, but try it and see.

Center Spot Filters

Center spot filters are variations of diffusion filters in which the center of the filter is either a clear spot or removed entirely. The size of the spot has been calculated by the filter manufacturer to produce its maximum effect with normal focal length lenses. This limits the versatility of such filters somewhat, since both the area of sharp focus and the amount of diffusion are predetermined and cannot be changed. When using this type of diffusion filter, you must either arrange your subject matter to match the filter's requirements or vary the camera-to-subject dis-

Try combining a diffuser with the use of other special-effect filters. A Camrex diffuser softens all three images in this 3T prism shot of Julie Swanson.

tance until the effect becomes suitable. The greatest amount of diffusion with center spot filters occurs at maximum apertures, with f/5.6 about the smallest practical lens opening for use. Stopping down to about f/8 often causes a halo of white light to form around the center spot, and once the aperture becomes equal to or smaller than the spot or cut-out area, no diffusion takes place.

Hoya's soft-spot filter is an interesting variation, since it comes with a pair of interchangeable filter screens. The soft-spot screen has an irregular and uneven surface surrounding the clear center. This slightly diffuses the image, but without causing distortion. As with the standard center spot filter, the minimum practical aperture remains about f/5.6; at smaller lens openings, the effect becomes minimal.

The alternate sand screen of finely ground glass has a slightly smoky appearance sur-

rounding the clear center. This not only diffuses the area surrounding the center, it also whitens it to produce a form of vignette. No exposure modifications are required with the soft screen, but you should meter only the clear spot when using the sand screen. This means stopping down to about f/11, taking your reading and manually adjusting the camera for a proper exposure at the shooting aperture. If you meter normally at full aperture, the ground glass will affect the meter reading and result in overexposure, which diminishes the white vignette effect. If this is not possible, meter your subject before installing the filter.

A third variation is called a color spot. This is simply a colored filter of optical glass with the center spot removed. Instead of diffusing the area around your center subject, it produces a colored ring. Despite the strong color of these filters, don't expect colors of the same strength to show up in your pictures—the effect turns out to be more of a medium tint at full aperture, lightening in color and diminishing in size rapidly as you stop the lens down. Color spots have little value with black-and-white film, but can be combined with center or soft-spot filters for a colorful diffusion effect when color film is used. All of the center spot filters work best when your intent is to isolate the subject in the center of the picture—whether it's a flower, a person, or some other single object.

Homemade Diffusion

At the opening of this chapter, I briefly mentioned a few of the many do-it-yourself diffusers—petroleum jelly, nylon mesh, etc. Here are a few more hints on using homemade diffusers with petroleum jelly. If you have a filter gel holder, apply a light coat of petroleum jelly to a piece of clear glass or acetate cut to fit the holder. The thickness of the coating will determine the amount of diffusion. By leaving the center of the glass or acetate clear, you can create your own center spot filter.

Try varying the spot effect by attaching the glass or acetate to the outside of your lens hood. This greater separation between lens and filter will affect the amount and degree of diffusion, as well as reduce the size of the clear spot. Since a wide aperture is necessary to get the full effect of the center spot, you can use a neutral density filter to control the size of the lens opening. Should depth of field be important for some reason, you'll have to increase the strength of the diffuser or use a combination of two or more.

David Neibel used a center spot filter to play down the background and focus attention on his subject.

A different effect can be obtained by dragging a stiff brush lightly over the surface of the petroleum jelly. The lines created in this way will refract the light in a pattern and increase the interest in the soft-focus area of the image. To keep dust and dirt from contaminating the petroleum jelly while you're working, insert the glass or acetate in the filter holder with the coating facing the lens.

If petroleum jelly is too messy to work with, try spraying a matte protective spray lightly across the surface of the sheet of glass or acetate. This one's tricky, but if you apply just the right amount of the spray, it will produce a superb diffusion filter which will deliver an outstanding soft-focus effect and you don't have to worry about smearing the stuff or trying to apply just the right amount to recreate the effect at a later date—the matte spray will dry in place and the "filter" thus created can be reused as often as you wish as long as you take the pains necessary to protect the surface from degradation.

Throughout this book, you've come across references to experimentation and creativity/imagination. These factors are constantly in demand whenever you hope to take more than a snapshot, and they apply to the use of diffusion as well as the other special effect filters covered within these pages. Don't be afraid to experiment and don't let minor failures to achieve just the right effect frustrate you—it's all part of the learning process.

Jennifer Pelley used a Hoya center spot filter to emphasize the unusual combination of bridge and reflection in this New York City park.

HEIGHTEN THE EFFECT

There are times when you'll encounter a subject which doesn't seem to benefit from the use of a particular filter as much as you thought it would. This is particularly true of the color spot filters. Their effect is considerably different than the filters' appearance would lead you to believe. Color spot filters do not provide a perfectly circular effect with rectangular negative formats, but one that is stronger on each end than at the top/bottom of the frame. Exact subject placement within the spot area may be difficult to control, further complicating its effective use.

If the color spot filter fascinates you, try combining its use with that of a black-and-white contrast filter for really striking effects. The contrast filter will impart its own color to the clear center and change the color ring effect only slightly. For example, using a medium yellow contrast filter with a red color spot will bathe the subject in a warm yellow tone which blends into a deep red ring. A light green or yellow contrast filter works well with a blue color spot; a light blue color-compensating or yellow contrast filter is also attractive when used with the green color spot. The choice of color combinations depends primarily upon the subject and your personal preference, but generally speaking, the center color should be lighter in hue than the color ring provided by the color spot filter.

A little experimentation on your part will turn up other ideal combinations when using the color spot filter. A five- or six-segment prism attachment will produce a clear center image surrounded by colored refractions; a medium-strength diffusion filter will heighten the color ring effect by softening it at the same time it softens the clear center image. Put your imagination to work and don't be afraid to combine two or three filters to try out the effect—you'll be pleasantly surprised in many cases, and the slight loss (if any) in image definition shouldn't be noticeable enough to detract from the striking effect you've created.

"Pop" Filters

Used in the same way as normal black-and-white contrast filters, these are intense single-color filters used to produce an overall cast on color film. They differ from ordinary black-and-white contrast filters mainly in the result. While ordinary contrast filters will deliver a yellow, orange, green or red cast, these make a color picture "pop" with vibrant color, hence their name. Pop filters deliver strong and unusual shades of purple, pink or aquamarine which are not obtainable on color film with other filters.

If you'll pardon the poor pun, pop filters are not as popular as they once were—several brands have disappeared from the market in recent years. To my best knowledge, only three varieties still remain available—Kalt V + V Exoticolor, Spiratone Vibracolor, and Hoya Pop. When you find a subject suitable for use with "palpitating pink" or "mystic marine," the result

can be eye-blowing and even mind-bending, but that's also the major limitation of a pop filter. It's not always easy to match a suitable subject with the filter, and if the two are not compatible, the result is usually a visual "blah." Filter factors differ with the color and manufacturer, but all require some increase in exposure when used.

Hoya's Pop filters differ from those offered by Kalt and Spiratone in that they come in intense shades of red, blue and green, similar to the PRO Tri-Color filter set. These are roughly equivalent to the Kodak Wratten No. 25 (red), No. 38A (blue) and No. 61 (deep green) filters, and have a somewhat different use from the V + V Pop and Vibracolor filters—they can be used when it is desired to approximate the effect of a Harris shutter.

For those who are not familiar with the Harris shutter (named for its inventor, Robert Harris of Kodak), this amounts to three gelatin filters attached side-by-side to a frame with a section of black cardboard at each end to form a filter strip. This filter strip is then inserted vertically into a box frame attached to the front of the lens with one of the black ends covering the lens. The camera shutter is opened on its "B" setting and the strip dropped in front of the lens, stopping when the other black end blocks the light again.

Once you close the shutter, you've taken a multicolored time exposure. Anything in the scene which did not move will appear normal, since the picture was taken through the three primary colors which constitute white light. But anything that moved will appear in rainbow-like colors. Some of the most popular subjects for this effect are crashing waves on a rocky seashore, a water fountain and a flag waving gently in the breeze.

If you'd like, you can make your own version of the Harris shutter. Complete directions, drawings and instructions for use are provided in Kodak's *Seventh Here's How Book* (Publication AE-90). Since the effect can be duplicated with

Left:
Pop filters work best to emphasize a prevailing mood or completely change it. This foggy beach scene was shot at dusk. Using a "mystic marine" pop filter with color film would enhance the effect considerably, changing the characteristic grayness of fog to a strikingly dramatic brilliant purple.

many subjects by using the three Hoya pop filters or their equivalent, you'll undoubtedly find them to be an easier and less expensive introduction to producing multicolored time exposures. Remember—if *nothing* moves in your picture, there will be absolutely *no* color fringing. The subject selected must have *some* slight degree of motion without moving out of the picture area while you make three consecutive exposures on the same frame of film. Here's how it's done.

Select your subject and mount the camera on a sturdy tripod. Compose the picture and determine the correct exposure. Some photographers prefer to increase the exposure by one f-stop, while others recommend decreasing it by the same amount. I'd suggest that you bracket—make one triple exposure at one stop larger than the meter reading, one at the meter reading, and a third at one stop smaller. Once you see the results, you'll be able to pick the effect which suits your taste best.

If your camera has a provision for multiple exposures, simply make three exposures—one through each filter—without advancing the film. If no specific control is provided, depress and hold the film rewind button/lever while you move the film advance lever to cock the shutter. With this method, you can expect the film to slip a bit each time the technique is used. This will cause slightly out-of-register images, each of which will have a color fringe equivalent to that of the filter used. With some subjects, this fringing will add to the impact but it may prove distracting with others.

Variations of the three-filter, multiple-exposure technique can also be used with stationary subjects. In this case, you move either the subject or the camera between exposures to overlap the colors. How much and in what direction will depend upon the subject and how you choose to interpret it. You can also light the subject differently for each exposure. This will result in some spectacular results, since most parts of the subject will receive different amounts of light during each exposure. When such overlap occurs, you'll pick up tinges of magenta, cyan and yellow. Color negative film is the best choice with pop filters, since any small errors in exposure or color balance can be easily corrected when printing the negative.

Gallery

Fog Filter (Mike Stensvold)